POSTCARD HISTORY SERIES

Jacksonville Revisited

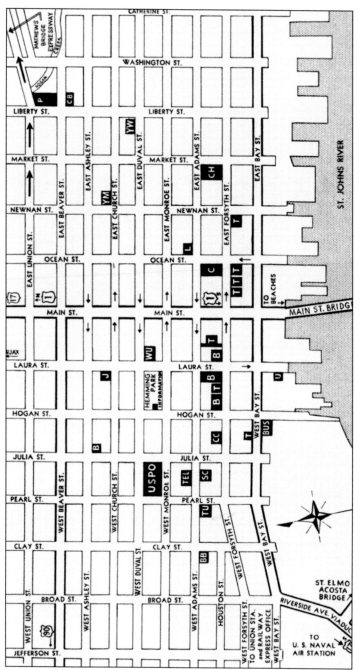

A map, from a visitors guide to Jacksonville, Florida, shows Jacksonville's downtown business district. (Jacksonville Advertising Committee.)

ON THE FRONT COVER: This is a pre-1907 view of Bay Street looking west toward the Grand National Hotel. (Authors' collection.)

ON THE BACK COVER: This aerial view of Bay Street documents the rapid growth and development nine months after the Great Fire of 1901. (Authors' collection.)

POSTCARD HISTORY SERIES

Jacksonville Revisited

Andrew Bachmann and Maria E. Mediavilla
in association with the Jacksonville Historical Society

ARCADIA
PUBLISHING

Published by Arcadia Publishing
Charleston, South Carolina

Printed in the United States of America

Library of Congress Catalog Card Number: 2007921791

For all general information contact Arcadia Publishing at:
Telephone 843-853-2070
Fax 843-853-0044
E-mail sales@arcadiapublishing.com
For customer service and orders:
Toll-Free 1-888-313-2665

Visit us on the Internet at www.arcadiapublishing.com

Dedicated to Alan Magluta,
friend and fellow time traveler.
Thank you for introducing us to the wonders of postcard collecting.
Continue the journey, and good luck bidding!

Contents

ACKNOWLEDGMENTS

Jacksonville Revisited, supported by the Jacksonville Historical Society, tells the story of Jacksonville's past through postcards. Postcards provide the visual documentation and the starting point for this book. Most copyrights have long expired. However, credit is given after each caption, whenever possible, to the manufacturer and/or publisher of each postcard image. Information about each of the images was obtained through meticulous research, gathered from various locations and many sources. This was possible with the help of some very kind and knowledgeable people.

The "Vertical Files" from the Florida Collection at Jacksonville's Main Public Library proved to be a treasure trove of history. Each of the topical folders, "Hotels," "Restaurants," and "Camp Johnston," contained information from countless *Florida Times-Union* articles dating back to the 1930s and many other sources. A special thank you to Raymond Neal, Andy Barmer, Louis Zelenka, and the entire staff in the Special Collections Department. You made the hunt for information more fun and much easier.

Thank you Eileen Brady. The University of North Florida's Special Collection provided many valuable clues to what life was like for residents and tourists visiting Jacksonville during the 1900s.

Thank you Joel McEachin, principal planner, for sharing the road to historic discovery.

Thank you to Ken Stanford and all the old-timers who took the time to share a story. Personal accounts add validity and uniqueness to an event or time period.

Thank you Dr. Ann Opalak Bachmann, "Mom," for all your English lessons and valuable editing talents.

Thank you to Carole Fader for your amazing editing skills.

Thank you to Emily Lisska, executive director of the Jacksonville Historical Society. Your wisdom, editing skills, and kindness are deeply appreciated.

This book was only possible because of the postcards collected and the mountains of information provided through some of the most complete and factual sources of written text. Ed Mueller beautifully illustrates life during the steamboat days and how this time period influenced Jacksonville's growth and development. Dr. James Crooks, T. Fredrick Davis, and Dr. Wayne Wood have each written some of the best historical accounts of events and basic life in Jacksonville. Thank you for the journey on which your written work has taken us.

And a very special thank you to the late Glen Emery, who enthusiastically shared the "Jacksonville Story" and his love of history.

INTRODUCTION

Jacksonville Revisited is the second book in a series of postcard history books written in conjunction with the Jacksonville Historical Society. These books tell the story of Jacksonville, Florida, through postcards.

A postcard begins as a photograph, and then it becomes something much more. They allow us to travel back in time as we peruse these small printed mementos of yesteryear. Postcards present us with images that are both nostalgic and idealized. They represent the photographer's best effort to illustrate a scene, often to glorify it, and always to encourage someone to buy it.

Postcards are miniature works of art, sometimes wonderful and sometimes not. Many are artistically altered—hand painted, colorized, embossed, and touched up—with structures, objects, and people sometimes erased or added to the postcard scene. This makes them no less valuable as messages from the past.

In addition to their images, postcards can also be historical written documents. They are often inscribed with a caption written on the card, describing the subject of the picture. The outward function of a postcard is to serve as a brief hand-written communication between two or more people, with the image on the card embellishing the writer's message and often highlighting their visit to a place of interest. Postcards travel through the mail as a visual reward to the recipient.

Collectively, these postcards tell the story of Jacksonville. They remind us of what we were. Some of the postcards show images of places and buildings long-gone, and others show landmarks that have survived. The demolished buildings, once so beautiful that they were captured on a postcard, evoke in us a sense of loss. The survivors testify to the proud and enduring richness of this city's heritage.

In this book, the authors, Andrew Bachmann and Maria E. Mediavilla, share with us their passion for postcard collecting, as well as their knowledge of Jacksonville history. After moving to Jacksonville, Florida, in 1992, this husband-and-wife team has collected over 2,500 Jacksonville postcards, in addition to those of other locations and topics. The postcards presented in this book are from their personal collection, which has been digitally archived. Their Web site—www.FLAJAX.com—is a vault filled with vintage postcards from all over the state of Florida.

This book is a valuable history lesson told with rare images, illuminating text, and a passion for historic preservation.

—Dr. Wayne W. Wood

BIBLIOGRAPHY

Crooks, James B. *Jacksonville After the Fire, 1901–1919, A New South City*. Gainesville, Florida: University of North Florida Press, 1991.

———. *Jacksonville, The Consolidation Story, From Civil Rights to the Jaguars*. Gainesville, Florida: University Press of Florida, 2004.

Davis, T. Frederick. *History of Jacksonville, Florida and Vicinity, 1513 to 1924*. Jacksonville, Florida: Mike Blauer, 1925, Reprinted 1990.

Gold, Pleasant Daniel. *History of Duval County, Florida*. Salem, Massachusetts: Higginson Book Company, 1928, Reprinted 1990.

Jacksonville City Directory. Jacksonville: J. Wiggins and Company, 1900, 1901, 1902, 1903.

Jacksonville City Directory. Jacksonville: R. L. Polk and Company, 1904–1985.

Martin, Richard A., "1918: The Year of the Lost Illusion" *Florida Times-Union* Centennial Edition, December 27, 1964.

Mueller, Edward A. *First Coast Steamboat Days*. Jacksonville, Florida: The Jacksonville Historical Society, Inc., 2005.

Northeast Florida Regional Ephemera Collection. Tourism, Hotels, Motels and Lodgings. Manuscripts and Personal Papers, Thomas G. Carpenter Library, University of North Florida.

Rust, Marian J. *The Healers, A History of Health Care in Jacksonville, Florida 1791–1986*. The Memorial Health, Education and Research Foundation, 1986.

Shepherd, Rose. Interview with Blair Burwell. June 2, 1939.

Smith, Charles H. *Jacksonville and Florida Facts*. The H. and W. B. Drew Company: Jacksonville, Florida, 1906.

The Port of Jacksonville, Florida, Port Series No. 8, Part I. Washington, D.C.: U.S. Government Printing Office, Revised 1937.

Williamson, Ronald M. *NAS JAX, 1940–2000: An Illustrated History*. Paducah, Kentucky: Turner Publishing Company, 2000.

Wood, Wayne W. *Jacksonville's Architectural Heritage—Landmark for the Future*. Revised ed. Jacksonville Historic Landmarks Commission, Gainesville, Florida: University Press of Florida, 1996.

One

THE ST. JOHNS RIVER

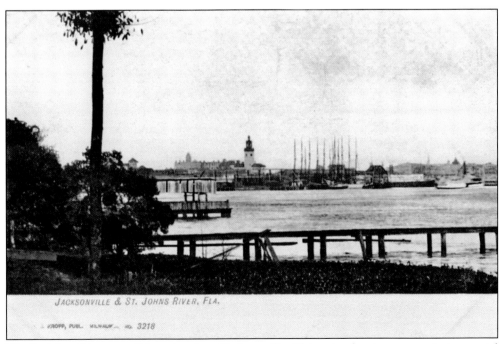

JACKSONVILLE & ST. JOHNS RIVER, FLA.

KROPP, PUBL. MILWAUK. NO. 3218

The St. Johns River gave life to the city of Jacksonville. This natural waterway was instrumental in populating the area and supporting the growing community. Congress recognized Jacksonville as a "port of entry" in 1822. This pre-1907, undivided-back postcard shows the Jacksonville waterfront and the post office tower. (E. C. Kropp Company.)

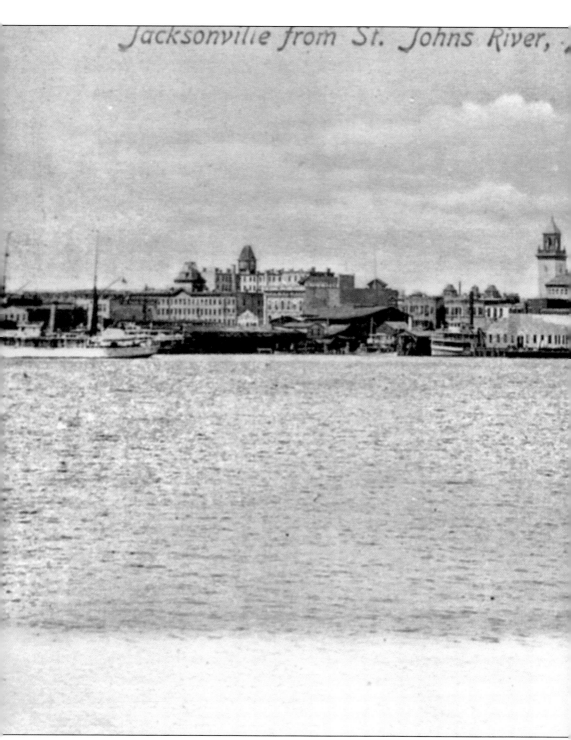

Sailing ships were instrumental in bringing early settlers to Florida. These ships were dependent upon wind and water conditions, which in turn made regular schedules impossible. Penetrating inland waterways was especially difficult for these vessels. Steamboats transformed the river into a busy passageway for people, goods, and supplies. The *George Washington* was the first

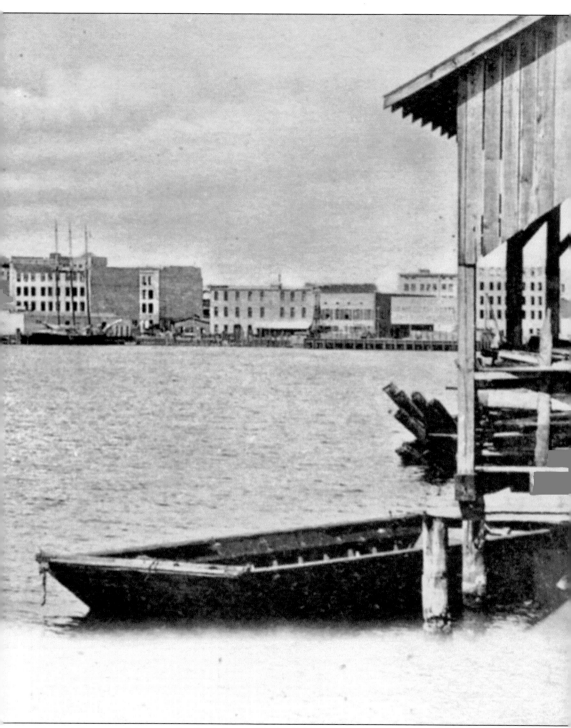

side-paddle steamship to arrive in Jacksonville in 1829; however, it was not until 1834 that the first, regular, once-a-week service began from Savannah, Georgia. This image is from a pre-1907 undivided-back postcard. It shows a busy waterfront and the Everett Hotel to the left. (National Art Views.)

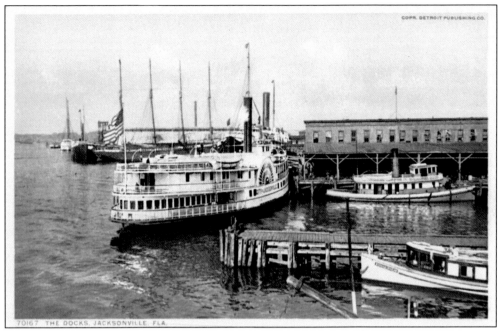

The DeBary Merchants Line acquired the *City of Jacksonville*, an iron-hulled side-wheel steamer, in 1883. Crowds of spectators used to gather along the Laura Street wharf eagerly awaiting her arrival. During this time, steamships were a symbol of progress and served as centers of community activity. (Detroit Publishing Company.)

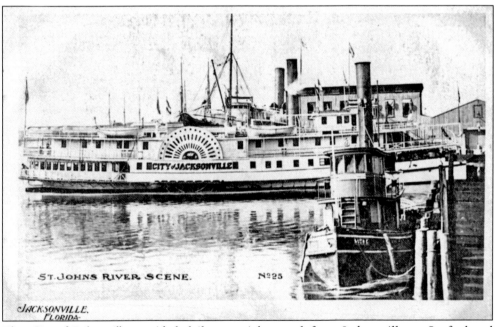

The *City of Jacksonville* provided daily overnight travel from Jacksonville to Sanford and Enterprise. This vessel was able to carry 275 passengers and had two freight compartments with iron cranes for hoisting freight. (The Albertype Company.)

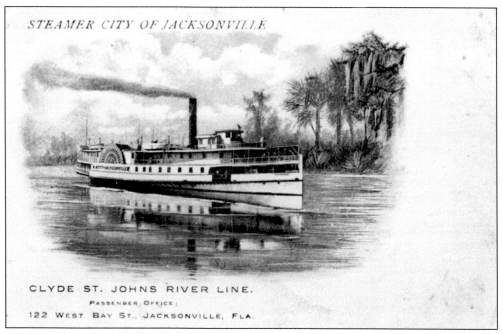

On December 16, 1888, the DeBary Line finalized the sale of its remaining steamships to the Clyde Line. These steamships included the *City of Jacksonville* and *Frederick DeBary.* The St. Johns River service was now advertised as the "St. Johns River Line." (The Albertype Company.)

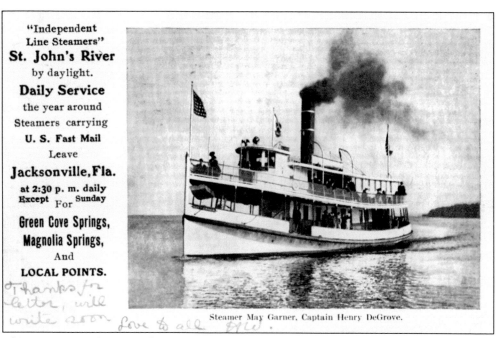

This 1906 postcard was an advertisement for the Independent Line steamers. Daily service from Jacksonville to Green Cove Springs, Magnolia Springs, and other local points was provided year-round. (J. C. Dexter Photo Company.)

Florida - South Jacksonville Waterfront,
showing Ferry Boats and Base Ball Park.

Residential development along the south bank of the St. Johns River began after the Civil War. By 1885, a ferryboat crossed the river every half hour, thus connecting the south side to the rapidly growing downtown. On the south side, homes were built on larger tracts of land and were far from the normal congestion of the downtown business section. The population grew to slightly over 600, and by 1907, South Jacksonville was incorporated as a town. This 1910 postcard depicts the South Jacksonville waterfront in the distance, showing numerous ferryboats and the baseball park. (H. and W. B. Drew Company.)

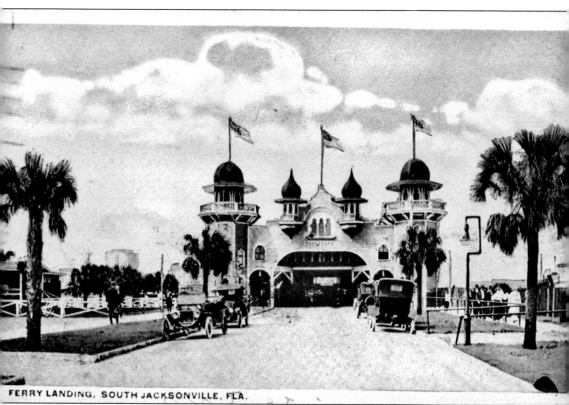

FERRY LANDING, SOUTH JACKSONVILLE, FLA.

By 1905, the South Jacksonville Steam Ferry Company operated the ferry service across the St. Johns River. This company built a bulkhead along the south side riverfront and then developed Dixieland Park in 1907. The park closed after several years because of fires and declining public interest. The ferry franchise was sold in July 1912 to the Ames Realty Company. The corporate name was changed to Jacksonville Ferry and Land Company. This company operated the Duval and South Jacksonville steam ferryboats.

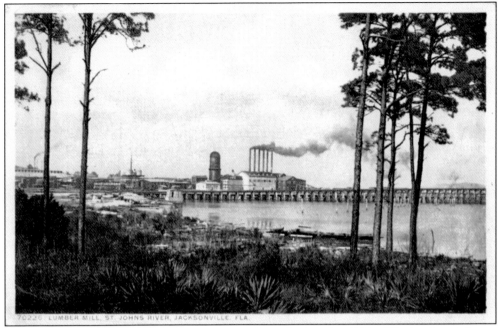

Numerous sawmills were built along the riverfront during the 1850s. The lumber industry continued to grow because of export along the St. Johns River and an abundant supply of yellow pine, cypress, and live oak timber. Jacksonville became a major center for lumber trade and, in turn, grew because of this and other commodities. (Detroit Publishing Company.)

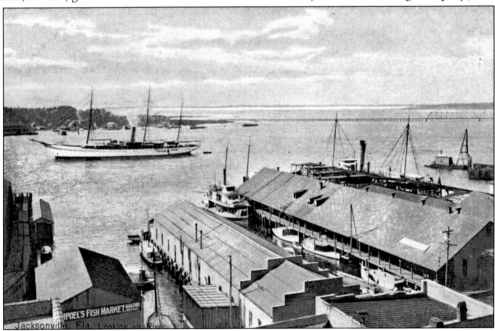

This postcard provides a view of the busy Jacksonville wharves and the Florida East Coast Railway Bridge, which opened in January 1890. Several different types of water transportation contributed to the growth and development of Jacksonville. (The Hugh C. Leighton Company.)

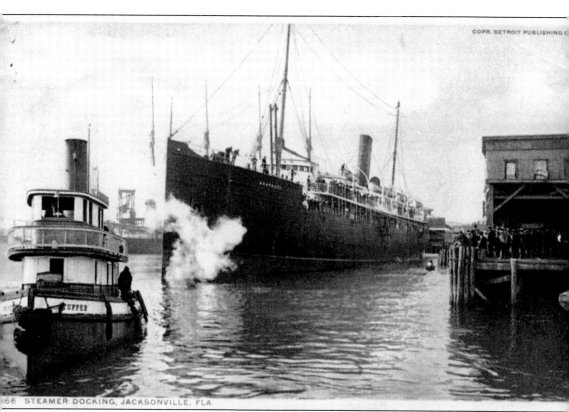

166 STEAMER DOCKING, JACKSONVILLE, FLA.

The Clyde Line, which already provided steamer service along the Eastern Seaboard, had plans to enter the Florida market. By the end of 1886, two of the Clyde Line's steamers, the *Cherokee* and *Seminole*, entered Jacksonville's port. Within 15 years, its fleet had grown and included the following steamships: *Iroquois, Yemassee, Algonquin, Comanche, Apache,* and *Arapahoe.* This postcard shows the *Arapahoe* arriving in Jacksonville. The *Arapahoe* was the first to dock at the newly improved Clyde Line terminal on May 15, 1911. (Detroit Publishing Company.)

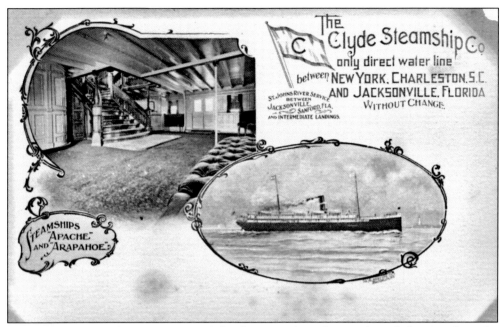

This is a pre-1907 advertising postcard for the sister ships the *Apache* and the *Arapahoe*. The Clyde Line provided coastal service, which connected the Northeast and the Southeast. These steamships also provided service to the West Indies and Mexico. Pictured is one of the two sister ships.

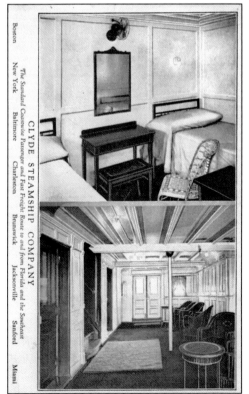

An interior view of a ship and one of its cabins is advertised on this Clyde Line postcard. The company was successful for many years. However, the advent of the railroad lured travelers and freight business from water travel.

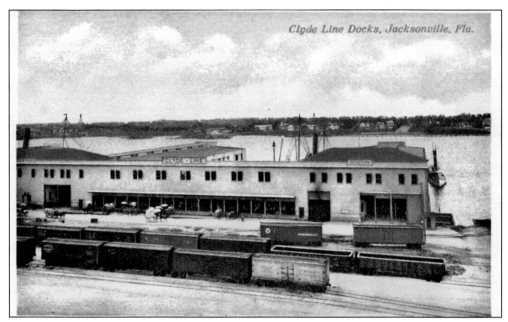

On September 15, 1889, a fire burned the Clyde Line pier at Hogan Street. Soon after, it was rebuilt and enlarged. The Clyde Line owned and operated two piers on the Jacksonville riverfront, but they had become inadequate. Almost two blocks of riverfront, between Washington Street (the location of Clyde's second pier) and Market Street, were acquired. The new and improved terminals were opened on May 15, 1911.

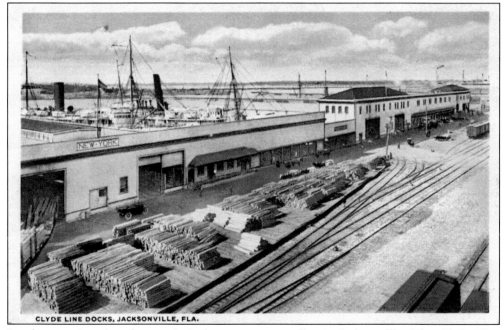

Lumber continued to be a principal export commodity in Jacksonville. The Clyde Line terminal had plenty of storage space for the lumber waiting to be loaded on the ships. Railroad spur tracks ran into each shed, thus allowing for easy transfer of cargo to and from the railroad cars. (H. and W. B. Drew Company.)

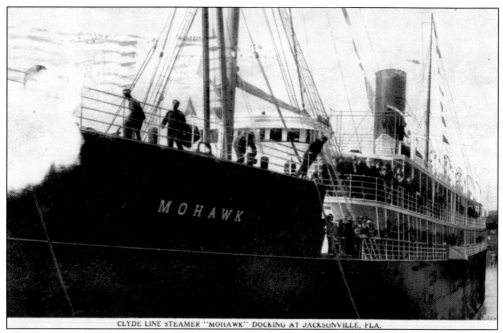

CLYDE LINE STEAMER "MOHAWK" DOCKING AT JACKSONVILLE, FLA.

The Clyde Line continued to add more ships to its fleet. The *Mohawk* made her first entrance into the port of Jacksonville on November 10, 1908. However, her career ended in 1925 when she sank in a collision with a freighter. (S. H. Kress and Company.)

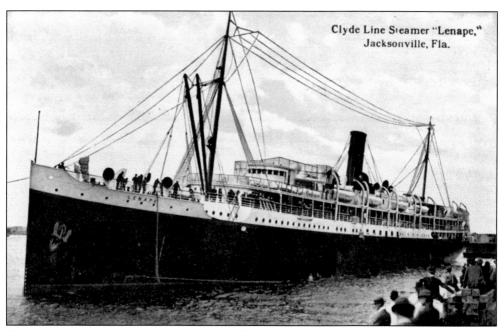

Clyde Line Steamer "Lenape," Jacksonville, Fla.

The *Lenape* was considered the queen of the Clyde Line fleet. She arrived in Jacksonville's port on January 24, 1913. (H. and W. B. Drew Company.)

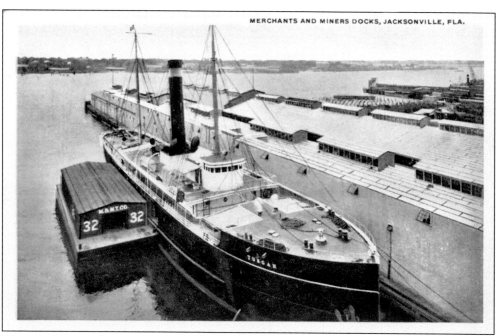

The Merchants and Miners Transportation Company extended its Baltimore-Savannah line to Jacksonville in 1909. It started its service with three sailings per week. The terminals, located on East Bay Street, were enlarged in 1911. A few months later, a Jacksonville-Philadelphia line was added. (H. and W. B. Drew Company.)

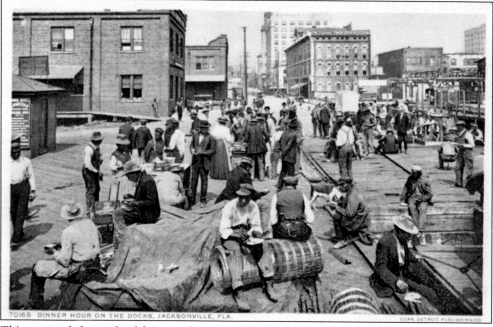

This postcard shows day laborers taking a dinner break on the docks around 1911. By 1936, there was a total of 62 wharves and terminals at the port of Jacksonville. Most of the terminals were equipped with railroad connections. During this time, the shipping and railroad industries were major employers in Jacksonville. (Detroit Publishing Company.)

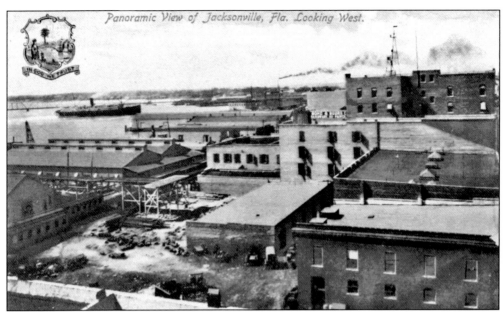

According to a 1936 report on the port of Jacksonville, 97 percent of the commodities exported from the port, on a tonnage basis, were naval stores, scrap iron, logs, lumber, and oyster shells. Approximately 90 percent of the imports received in Jacksonville consisted of fertilizer materials, creosote, paper goods, animal and dairy products, bananas, sugar, coffee, and other vegetable products. This postcard provides an aerial view of the storage facilities and terminals. (M. Mark.)

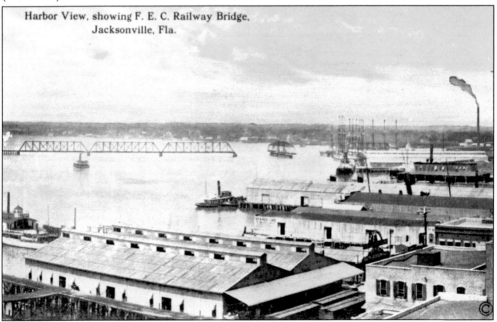

Henry Flagler created the Florida East Coast Railway system by buying and building railroads. Originally Flagler operated a steam ferry service to carry the railroad cars across the river. He eventually built an all-steel railroad bridge that crossed the St. Johns River beginning in 1890. The construction cost for this bridge was $1 million. (S. H. Kress and Company.)

Two

Transportation by Land and Air

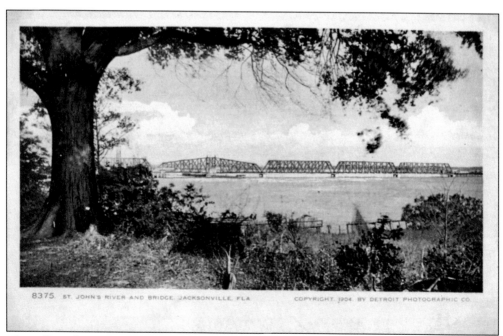

8375. ST. JOHN'S RIVER AND BRIDGE, JACKSONVILLE, FLA. COPYRIGHT 1904. BY DETROIT PHOTOGRAPHIC CO.

The yellow fever epidemic of 1888 kept the tourists away, while California lured them out West. By the end of the 1880s, Jacksonville was no longer the tourist mecca of the South. Once the railroad bridge was completed in 1890, the Florida tourists were now able to travel farther south and bypass Jacksonville. (Detroit Photographic Company.)

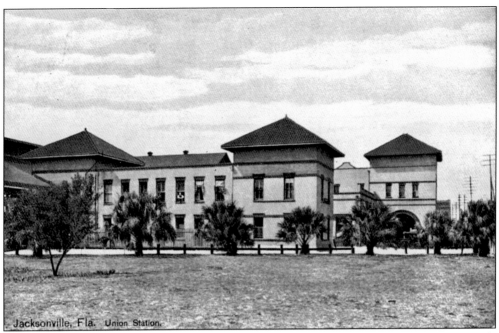

Jacksonville, Fla. Union Station.

During the last two decades of the 1800s, there were numerous railroad depots and terminals scattered about the city. Henry Flagler started the movement for a union station in Jacksonville when he purchased a plot of land in La Villa on July 24, 1890. Eventually the railroad companies agreed to build a consolidated depot on this site. (The Hugh C. Leighton Company.)

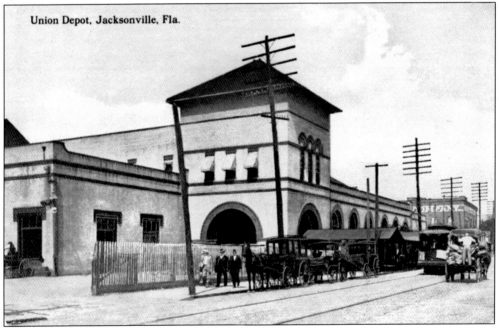

Union Depot, Jacksonville, Fla.

The Jacksonville Terminal Company was formed in 1893. Henry M. Flagler was president, and Henry B. Plant was vice president. Their purpose was to build the Union Terminal Station. It would have the necessary yards, tracks, and shop facilities for handling trains. (S. H. Kress and Company.)

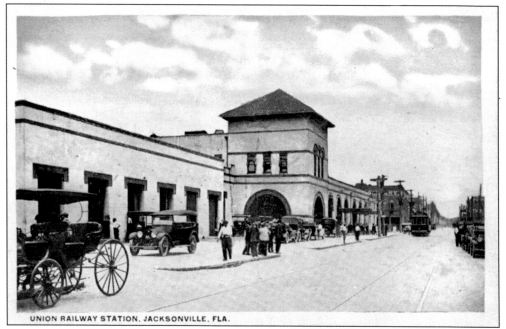

UNION RAILWAY STATION, JACKSONVILLE, FLA.

In 1887, Jacksonville annexed La Villa, a suburb on the west side of the city. This was the site of the future railroad depot, located near Lee and Bay Streets. Construction on the railroad depot began in 1893 and had a great impact on the La Villa neighborhood.

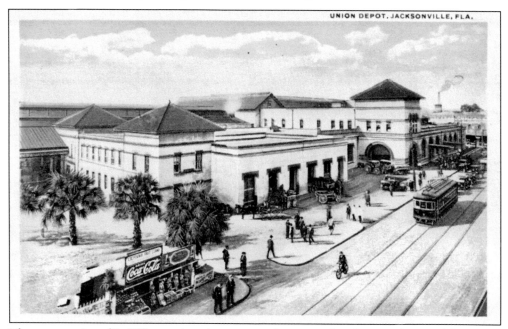

UNION DEPOT, JACKSONVILLE, FLA.

The community of La Villa continued to grow and prosper after the completion of the Union Terminal. "Many industrial and commercial enterprises moved into the surrounding area. Numerous rooming houses, small hotels, and bars prospered in the vicinity of the train station, catering to the transient visitors and railroad employees," according to *Jacksonville's Architectural Heritage, 1996.* (H. and W. B. Drew Company.)

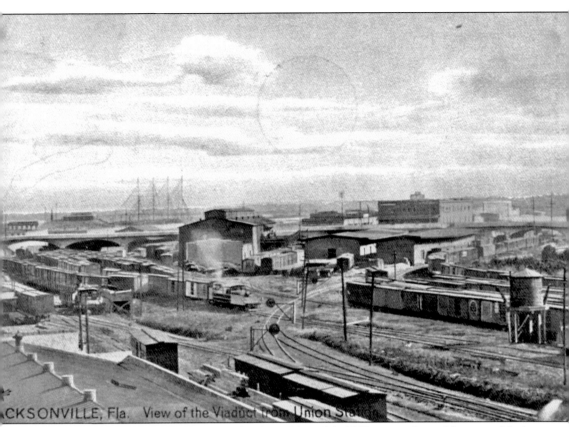

CKSONVILLE, Fla. View of the Viaduct from Union Station

The Broad Street Viaduct was completed in 1905. This 1917 postcard provides an aerial view of the viaduct from Union Terminal. One must look closely just below the horizon to see the viaduct in this very busy postcard scene. "This viaduct, which is one of the finest in the southern part of the country, is 1,110 feet long, and connects Riverside suburb with the city proper. It is crossed by a double street car line, and is also used by teams and pedestrians. The cost of construction was about $161,500," is printed on the back of this postcard. (Ralph Tuck and Sons.)

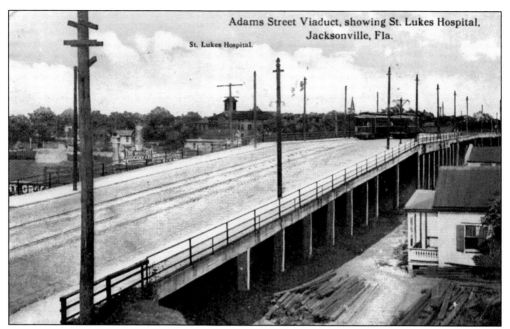

The Adams Street Viaduct over Hogan's Creek on the east side of Jacksonville was 1,400 feet long. It was completed in 1909. There were five approaches: two on Adams Street, two on Catherine Street, and one on Palmetto Street. This 1914 postcard shows St. Luke's Hospital, located on Palmetto Street, from the viaduct. (H. and W. B. Drew Company.)

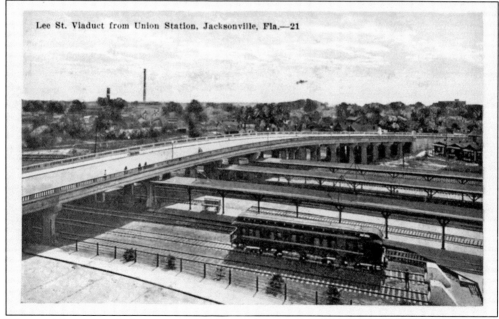

The need for a new viaduct over McCoy's Creek to Riverside was introduced in 1911 at a city council meeting. On September 1, 1919, there was a bond issue that included a provision for building the Lee Street Viaduct. However, construction did not start until the city completed its acquisition of privately owned property on Park Street in Brooklyn. The Lee Street Viaduct was completed on November 4, 1921. (E. C. Kropp Company.)

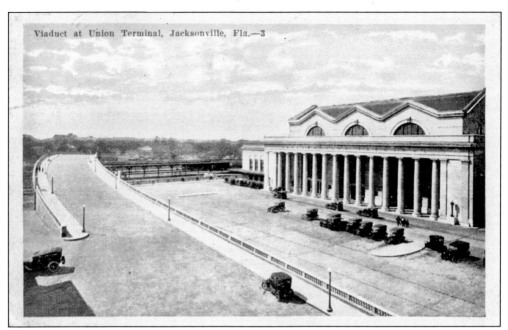

Construction on the Jacksonville Terminal began in 1917 and was completed in 1919. This was the largest railroad station in the South and was built jointly by the Atlantic Coast Line, Florida East Coast, Seaboard Air Line, and Southern railroads. The station could handle up to 142 trains and 20,000 passengers a day. (E. C. Kropp Company.)

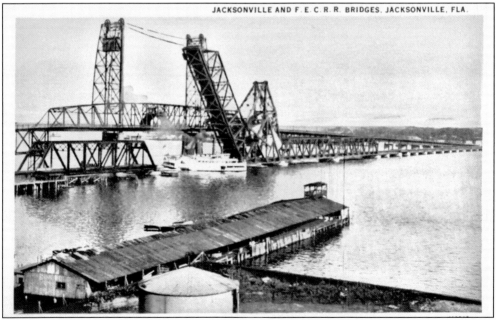

After 35 years of service, the original 1890 single-track railroad bridge was no longer able to handle the rail traffic for the east coast. By the end of 1925, a double-track bridge was completed and the original railroad bridge was demolished. This postcard shows a steamship going through the new railroad bridge and toward the Jacksonville–St. Johns River Bridge. (Duval News Company.)

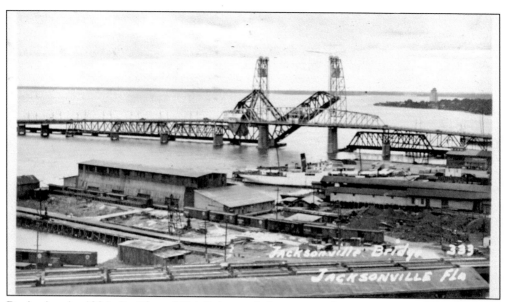

Beginning in 1904, St. Elmo "Chic" Acosta led an aggressive campaign to build the first highway bridge across the St. Johns River. The bridge was opposed by railroad and ferry boat companies, but the citizens of Jacksonville voted to construct the bridge. The Jacksonville–St. Johns River Bridge was completed on July 1, 1921, and the ferry boat business greatly declined. The last ferry crossed the river in 1938. In 1949, two years after Acosta's death, the bridge was renamed the St. Elmo W. Acosta Bridge.

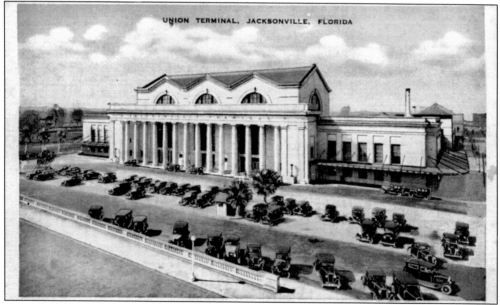

The Jacksonville Terminal is a monumental building that reflects the corporate pride and power of the Florida railway systems founded by Henry M. Flagler and Henry B. Plant. Architect Kenneth M. Murchison borrowed from the design of New York's Pennsylvania Station and won the competition for designing the new terminal. Jacksonville's 1919 train terminal was saved from the wrecking ball and, in 1986, was reopened as the Prime F. Osborn III Convention Center. (Duval News Company.)

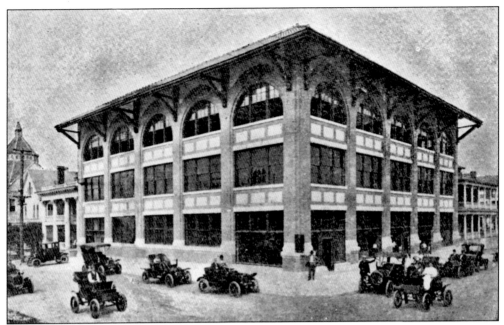

Fred E. Gilbert was an enthusiastic pioneer in the automotive business. He was an automobile dealer and opened the first garage in Jacksonville in 1904. Five years later, he opened this large three-story building. It had elegant showrooms and a complete garage where automobiles were stored, washed, repaired, and rented. The garage was located on the northwest corner of Laura and Church Streets from 1909 until 1912.

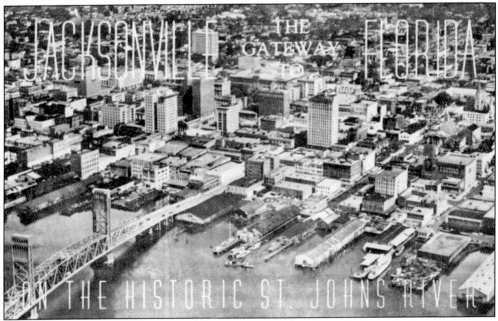

Jacksonville was the Gateway City into the state of Florida. All the main lines of travel—highways, skyways, railways, and waterways—met in Jacksonville, then spread to reach other parts of the state. This pre-1955 postcard provides an aerial view of the wharves and warehouses on either side of the Main Street Bridge.

After World War II ended, the shipping industry moved from downtown to the newer Talleyrand docks. The north bank was left with decayed and dilapidated warehouses and wharves. On July 18, 1941, the city's second vehicular bridge crossing the St. Johns River was opened. More commonly known as the Main Street Bridge, it was eventually given the name John T. Alsop Jr. Bridge. (Southern News Company.)

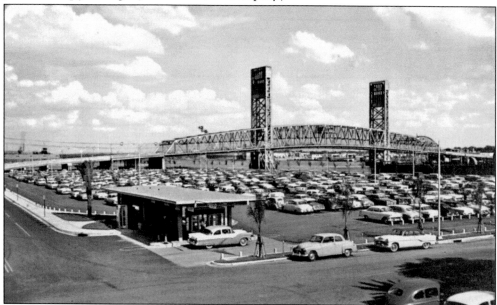

Haydon Burns was mayor of Jacksonville from 1949 to 1965. Burns was determined to renew the ugly north-bank riverfront on both sides of the Main Street Bridge. "Burns secured state authorization for $4 million in parking lot Certificate bonds, condemned, cleared, and filled land, constructed parking lots, and by 1955 had eliminated his first major eyesore," according to James B. Crooks, professor emeritus of history at the University of North Florida. (Duval News Company.)

During Jacksonville's Decade of Progress, Mayor Burns convinced the Atlantic Coast Line Railroad to move its headquarters from North Carolina to downtown Jacksonville. This postcard provides a view of the city parking lot in front of the new civic auditorium and, to the left, the new 15-story Atlantic Coast Line Railroad home office. (Duval News Company.)

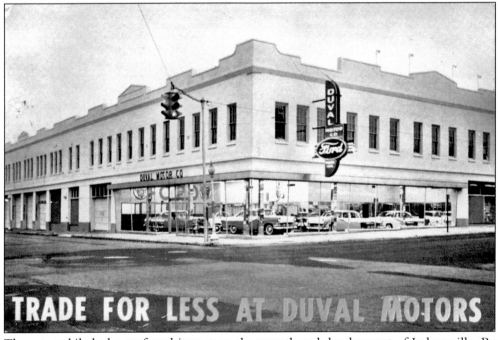

The automobile had a profound impact on the growth and development of Jacksonville. By the 1920s, cars were more affordable and most families had one. Duval Motor Company was located at 1005 West Forsyth Street on the corner of Lee Street. Cars were bought and sold in this indoor dealership from the 1940s to the 1960s.

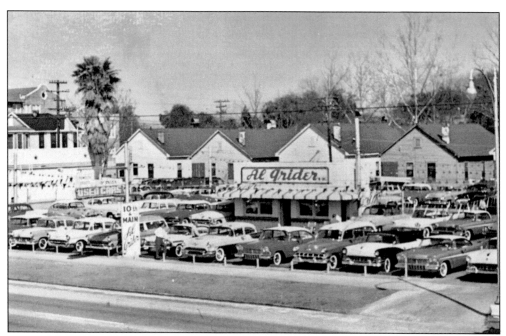

Engine power and vehicle speed rose during the 1950s. The automobile had become more reliable and more artful. At Al Grider's Car Lot, one could purchase "clean, used cars of all makes and models." During the 1950s, this car lot was located on Main Street between Ninth and Tenth Streets.

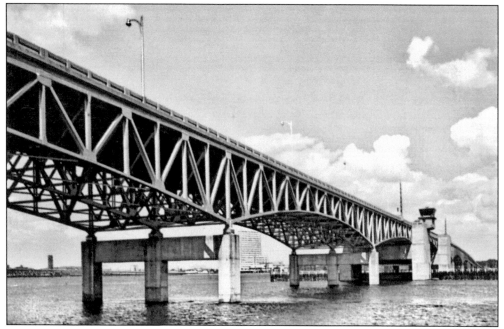

This postcard provides a close-up view of the original Fuller Warren Bridge, which was built in 1954. At the time, tollbooths on Jacksonville's highways and bridges led to bottlenecks and frustrated motorists. Mayor Tommy Hazouri successfully campaigned to eliminate the tollbooths, and on August 11, 1989, they were removed. (Duval News Company.)

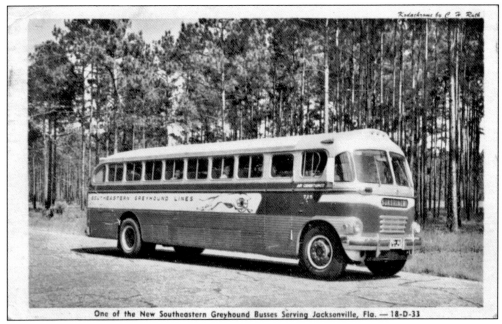

Kodachrome by C. F. Ruth

One of the New Southeastern Greyhound Busses Serving Jacksonville, Fla. — 18-D-33

Bus service was provided to places not serviced by the trains and during those times when trains did not run. This postcard was mailed in 1948, eight years before the start of the Interstate Highway System.

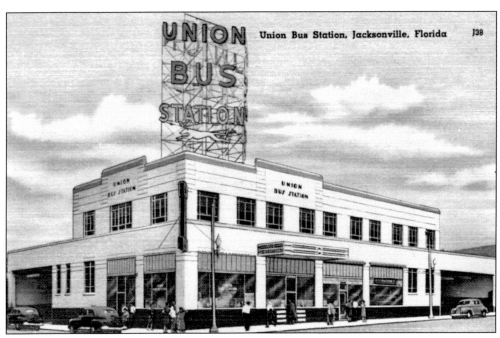

Union Bus Station, Jacksonville, Florida J38

The Florida Motor Lines Company owned the Union Bus Station until 1945, when Greyhound purchased it. The bus station was located at 200 West Bay Street on the corner of Hogan Street.

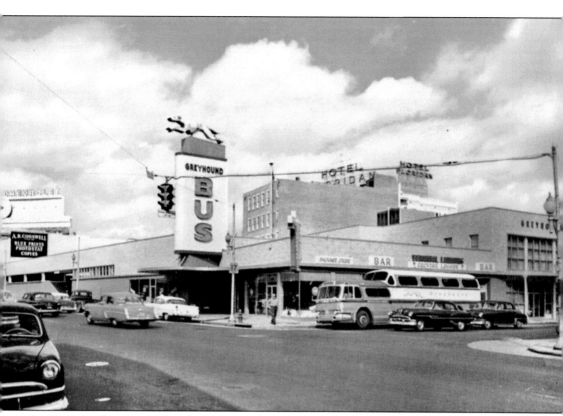

In 1956, the Greyhound Bus Station moved to 10 Pearl Street, its present location, where it provides bus service to and from Jacksonville.

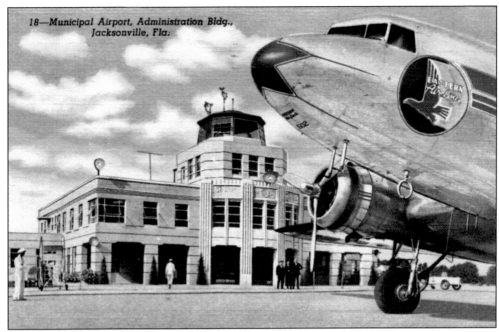

18—Municipal Airport, Administration Bldg.,
Jacksonville, Fla.

The Municipal Airport was built on 100 acres of the 175-acre City Prison Farm, located north of downtown Jacksonville. In 1926, a temporary landing field was constructed with the labor of city prisoners. On October 11, 1927, Charles Lindbergh flew the *Spirit of St. Louis* to Jacksonville's new municipal airport. He came to the airport's dedication to help promote the aviation industry.

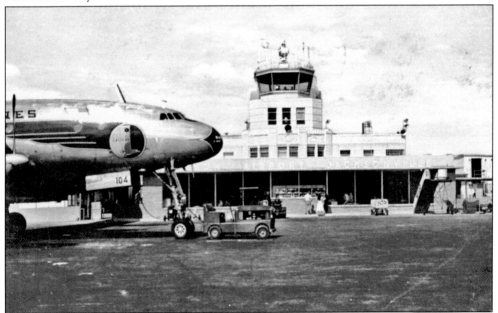

On January 1, 1931, Eastern Air Transport started the first regular passenger air service to Jacksonville. A small, wooden one-story terminal building was opened on the same day. Eastern Air Transport was later renamed Eastern Airlines. The new art deco–style terminal is shown in the two postcards above in 1941.

Three

JACKSONVILLE STREET SCENES

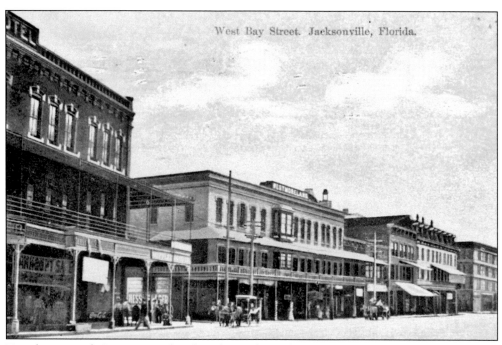

Travelers spent their money on hotels and steamboats, but large sums were also spent along the streets of Jacksonville. This 1915 postcard shows Bay Street, a road of commerce, where bazaars and souvenir stores were located. (O. T. Jones.)

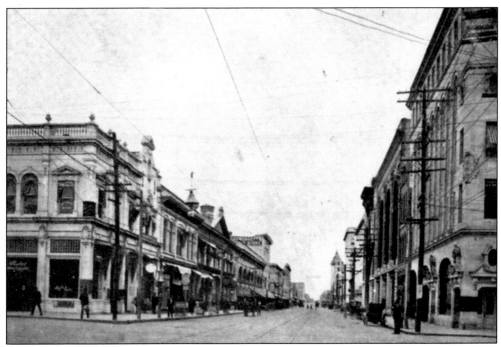

Jacksonville had become a thriving city, but on May 3, 1901, the Great Fire destroyed more than 2,000 buildings, thus changing the city's landscape. This pre-1907 postcard documents the rapid rebuilding of Bay Street. The Old Bisbee Building is pictured on the left. It was built soon after the fire, on the northeast corner of Laura and Bay Streets, and can still be seen today. (H. and W. B. Drew Company.)

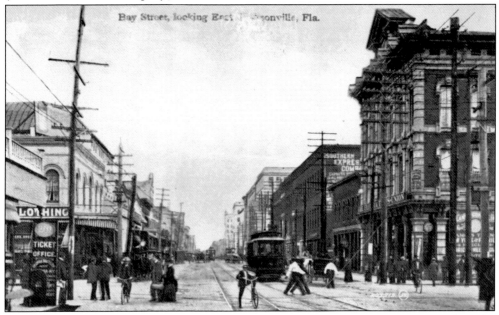

This 1907 postcard shows the busy intersection of Hogan and Bay Streets. At the time, bicycles were still a common form of transportation. The *Florida Times-Union* was a principal tenant in the three-story Astor Building on the far right. (Valentine and Sons' Publishing Company.)

38

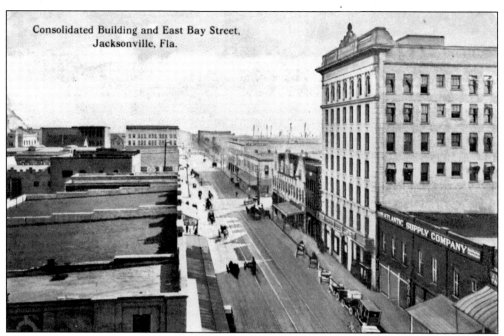

Consolidated Building and East Bay Street,
Jacksonville, Fla.

An aerial view of Bay Street looking east shows the seven-story Consolidated Building and the Herkimer Block. Both buildings were built soon after the fire of 1901. The Herkimer Block has unique stepped gables, numerous dormers, and arched windows. This building is easily recognized, even today. (S. H. Kress and Company.)

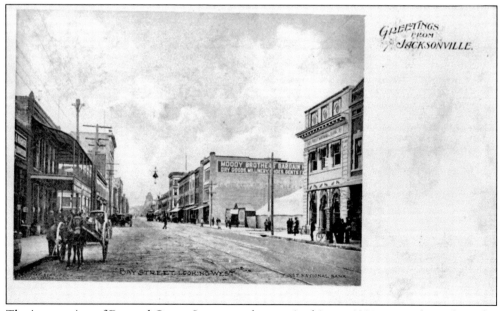

The intersection of Bay and Ocean Streets can be seen in this pre-1907 postcard. To the right, on the northeast corner, is the First National Bank Building. This 1902 building can still be seen today; however, a 1919 remodeling doubled the building's size. The expansion was so skillfully done that one cannot differentiate between the original building and the 1919 addition.

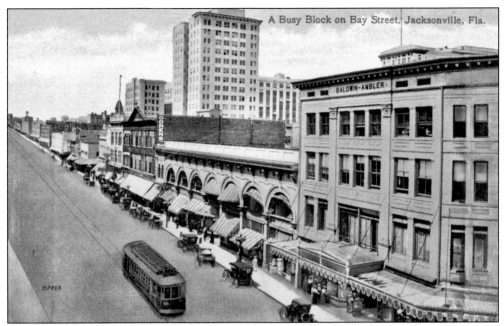

This postcard shows Bay Street from Main Street looking west to Laura Street and beyond. Businesses were rebuilt and expanded during Jacksonville's era of reconstruction. The Cohens retail store was located on this street prior to 1912. According to a 1905 advertisement, it was "the largest retail, dry goods house in the state."

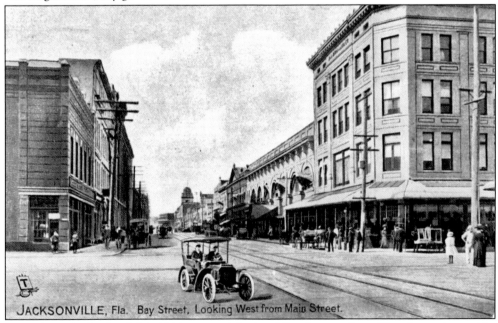

JACKSONVILLE, Fla. Bay Street, Looking West from Main Street.

Printed on the back of this 1916 postcard is the following caption: "Bay Street is a wide, brick paved thoroughfare extending east and west, and along its sides are many fine mercantile houses, West of Main Street are the two largest dry goods stores, wholesale grocery stores, and the West Building, besides many others. The shopping district is mostly in the first two blocks west of Main Street." (Raphael Tuck and Sons.)

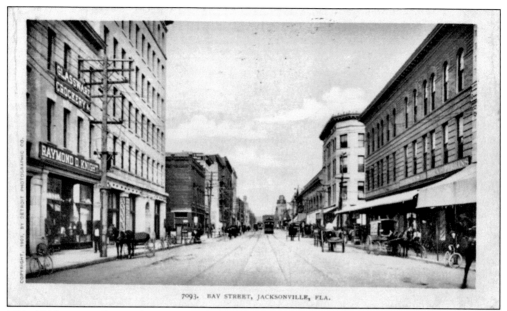

This 1903 postcard provides a view of Bay Street looking west. The first building on the left is the Knight Crockery Company Building. The company sold, in addition to crockery, household furnishings, china, and glassware. The Dyal-Upchurch Building is the second building on the left and is located on the southeast corner of Main and Bay Streets. It was the first high-rise structure to be built after the 1901 fire. Both buildings still stand today.

The message on this postcard was written by "J and M," and it has a January 5, 1907, postmark. They write, "You should have seen us sailing around this town today. Are in station now." This postcard provides a view of Bay Street looking east from Main Street.

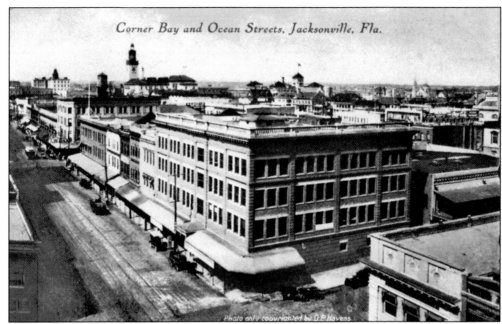

Corner Bay and Ocean Streets, Jacksonville, Fla.

This pre-1907 aerial view shows the northwest corner of Bay and Ocean Streets. The Windsor Hotel and post office can be seen in the background just above the horizon. The St. James Building and numerous skyscrapers were not yet built. (M. Mark.)

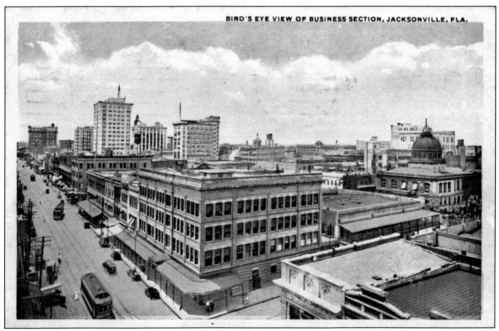

BIRD'S EYE VIEW OF BUSINESS SECTION, JACKSONVILLE, FLA.

Jacksonville's growth expanded greatly between 1907 and 1914. This postcard, dated 1920, provides an aerial view of the skyline from the same corner as the above postcard. The Windsor Hotel and post office are blocked from view. (H. and W. B. Drew Company.)

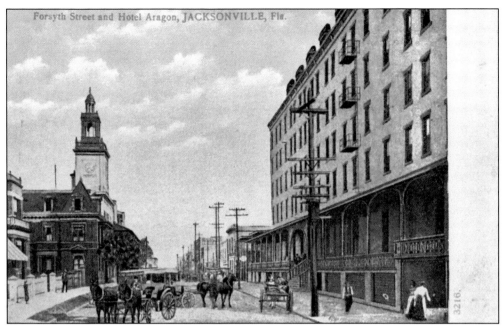

This pre-1907 postcard provides a view of Forsyth Street looking east. The Hotel Aragon is located to the right, and to the left, peering above the surrounding buildings, is the tower of the post office. Both survived the fire of 1901 but not the almost inevitable wrecking ball. (A. C. Bosselman and Company.)

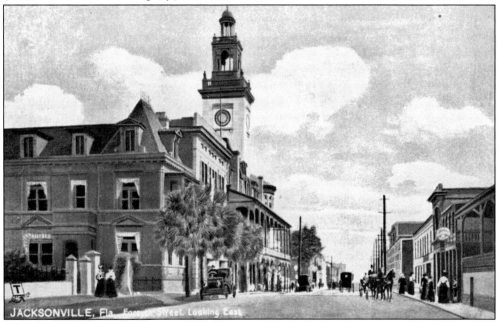

JACKSONVILLE, Fla. Forsyth Street Looking East

Printed on the reverse side of this postcard is the following description: "Forsyth Street is one of the fine business thoroughfares of the city, and extends east and west. Its sides are lined with stately and commodious buildings, among them being that of the National Bank of Jacksonville (the third oldest institution of its kind in the state), and the fine Mercantile Exchange Bank, erected since the fire of 1901." (Raphael Tuck and Sons.)

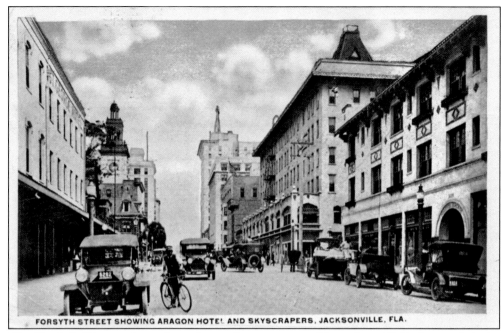

The Hotel Rollins was located on the southwest corner of Forsyth and Julia Streets. It is the first building on the right side of this postcard. The Aragon Hotel is also on the south side of Forsyth Street but across Julia Street. It is the taller, second building on the right side of this postcard dated 1924.

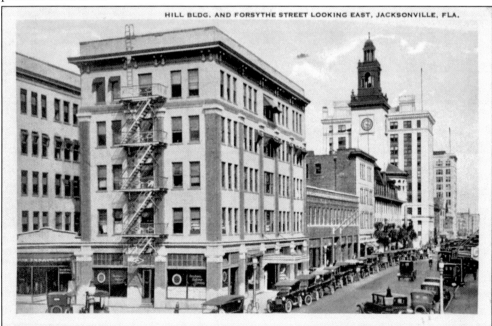

The Hill Building, featured on this postcard dated 1923, was erected in 1920 and was located on the northeast corner of Forsyth and Julia Streets. The name of the building was changed several times, the first in 1923 when it was renamed the Peninsular Casualty Building. Later it was changed to the Peninsular Life Building and then in 1954 to the O'Reilly Building.

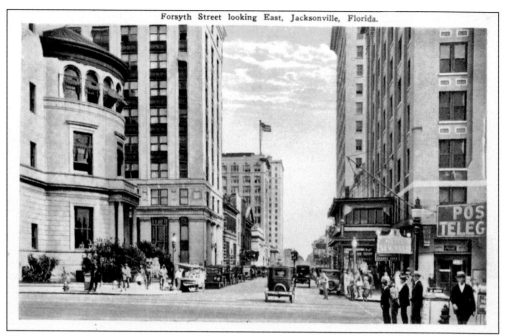

The rounded, three-story section of the 1895 Post Office is the first building on the left, on the northeast corner of Forsyth and Hogan Streets. Next to it is the Atlantic National Bank Building, which was built in 1909 and still stands today. The Seminole Hotel is located across the street on the southeast corner of Forsyth and Hogan Streets, the first building on the right. (E. C. Kropp Company.)

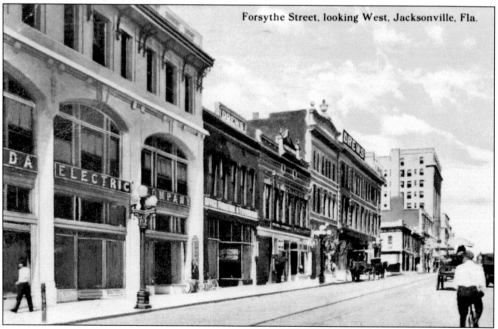

Forsythe Street, looking West, Jacksonville, Fla.

In 1902, electrical supplies could be found in the Florida Electric Company, located at 31–33 West Forsyth Street. It is the first building on the left. This was the second building on Forsyth Street from the southwest corner of Main Street. (H. and W. B. Drew Company.)

45

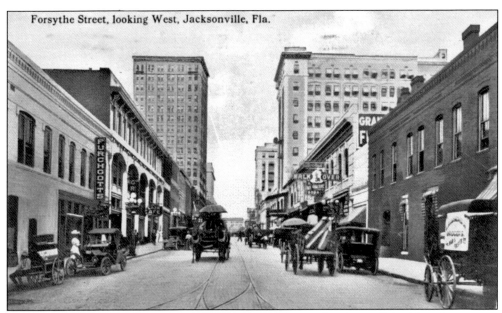

Forsythe Street, looking West, Jacksonville, Fla.

The building pictured on the far left is Furchgott's, one of Jacksonville's oldest department stores. It was the first building on the southwest corner of Main and Forsyth Streets. The second building is where the Florida Electric Company was once located. This postcard, dated 1914, also shows the 15-story Heard Building on the left and the 10-story Bisbee Building on the right. (H. and W. B. Drew Company.)

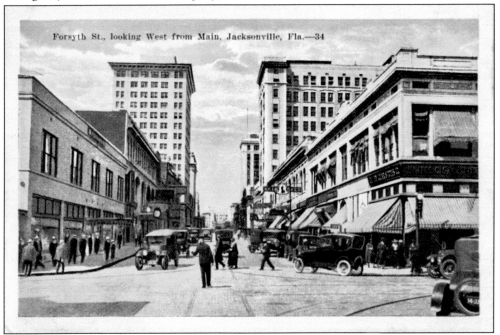

This is the intersection of Main and Forsyth Streets. The Woolworth's building is located on the northwest corner on the right side. Woolworth's 5 and 10¢ Store was the main tenant in this building when it opened in 1917. The structure was dramatically altered in the 1990s. (E. C. Kropp Company.)

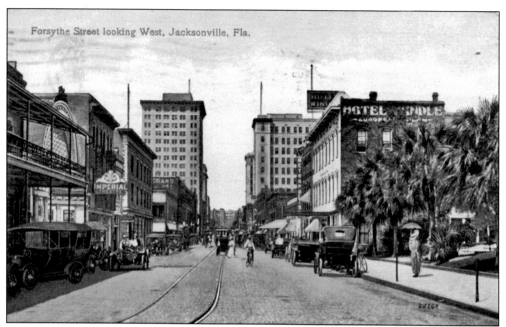

The Imperial Theater can be seen on the south side of Forsyth Street and the Hotel Windle and City Hall Park on the north side. This postcard, dated 1913, shows a trolley car going down Forsyth Street, along with automobiles and bicycles, in what was then the heart of the theater and shopping district.

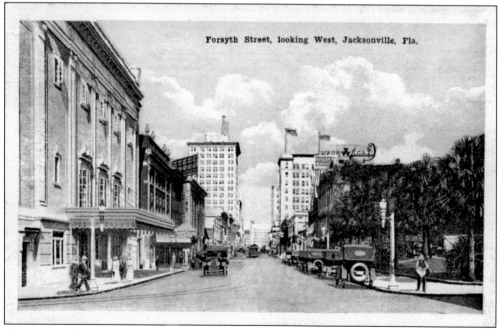

The Palace Theatre was located on the southwest corner of Forsyth and Ocean Streets, the first building on the left. It opened in 1919, just a few buildings away from the Imperial Theatre. In 1929, it cost 50¢ to see a show at the Palace Theatre and 40¢ at the Imperial Theatre. (E. C. Kropp Company.)

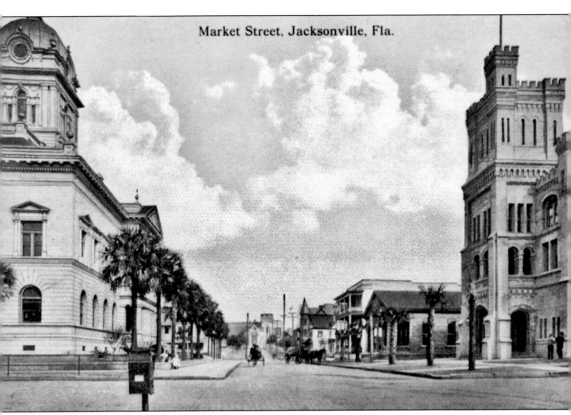

Market Street, Jacksonville, Fla.

The 1902 Duval County Courthouse was located on the northwest corner of Market and Forsyth Streets. It faced the 1903 Military Armory. This once brick-paved intersection has changed dramatically with the loss of the courthouse and armory. (H. and W. B. Drew Company.)

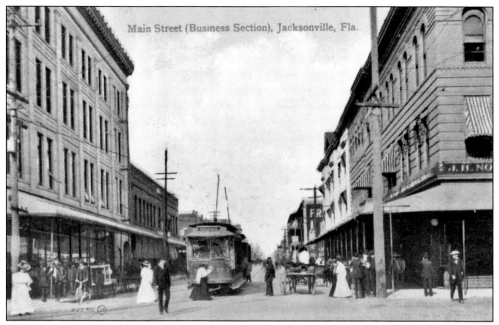

This 1915 postcard shows the busy intersection of Main and Bay Streets, looking north up Main Street. At the time, trolley cars were a common form of public transportation. This trolley line ran all the way to Cummer's Mill on the Trout River. (Valentine and Son's Publishing.)

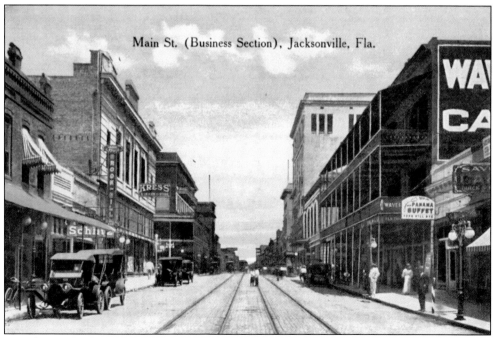

Two friends stop to chat in the middle of the intersection at Main and Adams Street. On the northwest corner of this intersection is the now long-gone Hotel Jackson. Across Adams Street from the hotel is the Kress store, a very large five-and-dime store completed in 1912. The building is still there, but the original tenants are gone. (S. H. Kress and Company.)

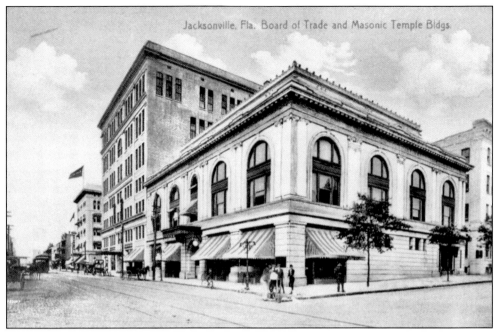

The handsome 1903 Board of Trade Building was located on the northeast corner of Main and Adams Streets. The Board of Trade was instrumental in many of the improvements that helped Jacksonville grow from a town to a city. (The Hugh C. Leighton Company.)

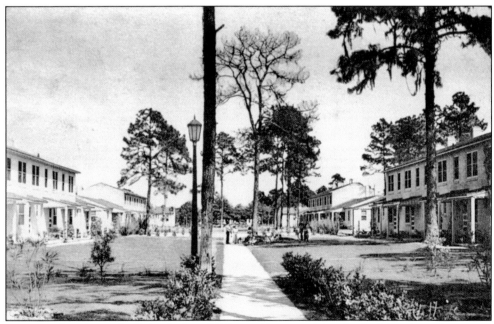

Brentwood Park was built in the late 1930s on 51 acres of farmland. Printed on the reverse side of this postcard is the following: "Scene from Housing Project in Jacksonville, Florida. Six hundred homes have been provided by the Housing Authority of Jacksonville in this development, consisting of 87 buildings, a Nursery School, and an Administration Building, which is the Central Office of the Authority." (Sunny Scenes, Inc.)

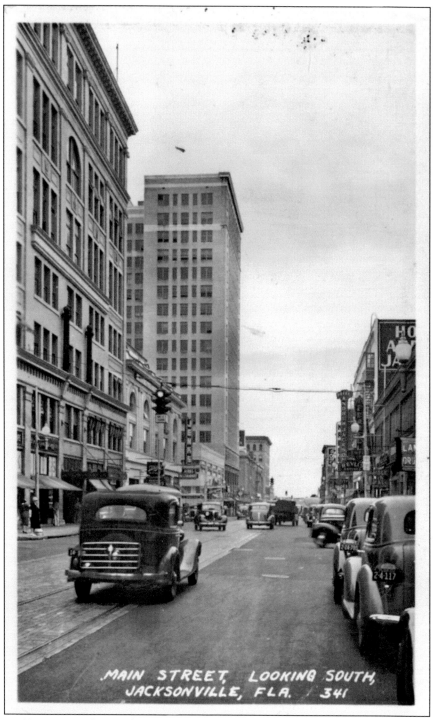

This pre–1941 postcard provides a view of Main Street looking south toward the St. Johns River. Jenks Restaurant has taken over the old Board of Trade Building, located on the northeast corner of Main and Adams Streets. The 17-story Lynch Building, erected in 1926, is located on the northeast corner of Main and Forsyth Streets.

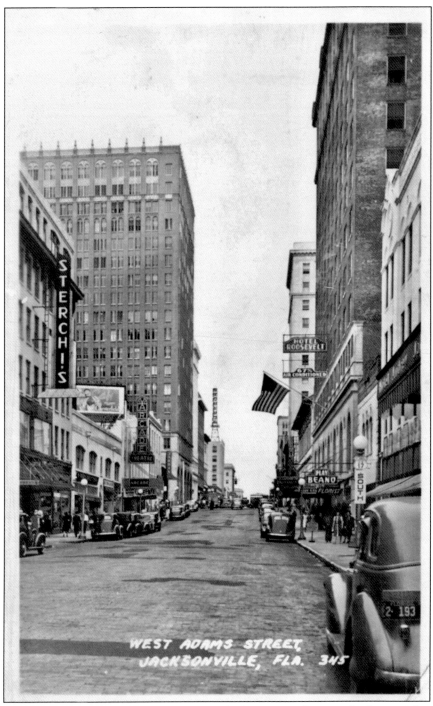

WEST ADAMS STREET,
JACKSONVILLE, FLA. 345

This real-photo postcard shows Adams Street looking west from Main Street. The Hotel Andrew Jackson can barely be seen on the far right, and towering above it on the same side of the street is the Hotel Roosevelt. The Arcade Theatre was located across the street on the south side of Adams Street in the center of the block. The theater was designed by Roy A. Benjamin and built in 1915. He also designed the Florida Theatre in 1926.

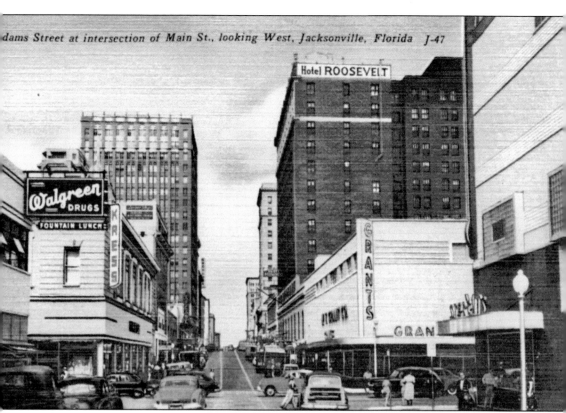

In the 1950s, W. T. Grant's Department Store took over the northwest corner of Adams and Main Streets. This was the original site of the Hotel Andrew Jackson, which was once two separate hotel buildings, the Hotel Jackson and the Hotel Albert. Across the street, on the southwest corner, was the 1912 Kress building after an extensive alteration of the first-floor facade. (Tichnor Quality Views.)

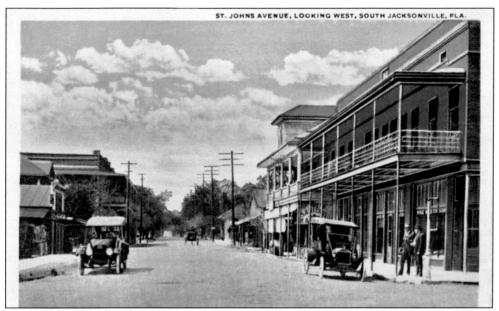

In 1907, the population of South Jacksonville was slightly over 600. The completion of Atlantic Boulevard in 1910 (as well as the railroads) contributed to its continued growth and popularity. St. Johns Avenue was located in South Jacksonville. However, on August 22, 1933, its name was changed to Miami Road, which eventually was changed again to Prudential Drive. (H. and W. B. Drew Company.)

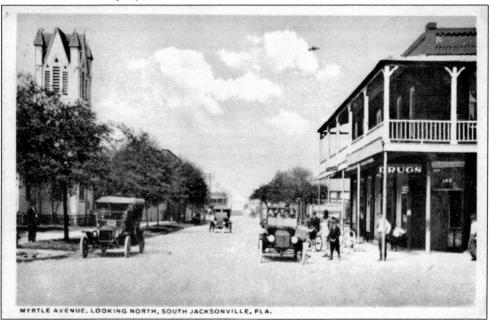

MYRTLE AVENUE, LOOKING NORTH, SOUTH JACKSONVILLE, FLA.

The completion of the St. Johns River Bridge in 1921 made South Jacksonville more accessible and popular. The area was transformed as new subdivisions were built. According to the 1924 City Directory, Myrtle Avenue (shown above) was located one block south of St. Johns Avenue and one block east of Hendricks Avenue. This road no longer exists. (H. and W. B. Drew Company.)

Four

HEMMING PLAZA

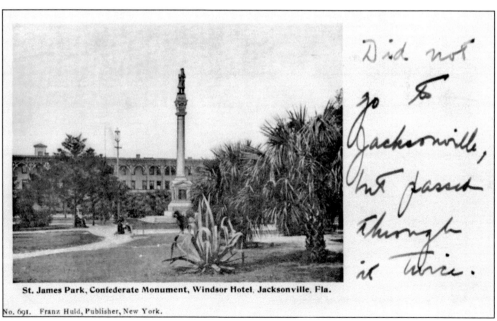

St. James Park, Confederate Monument, Windsor Hotel, Jacksonville, Fla.

No. 691. Franz Huld, Publisher, New York.

In 1857, thirty-five years after he helped lay out the town of Jacksonville, Isaiah D. Hart proposed setting aside this block as a public square. But it was not until 1866—five years after Hart's death—that his heirs conveyed this property to the city for $10. This postcard shows the park just before the Great Fire of 1901, with the Confederate Monument and the Windsor Hotel. (Franz Huld.)

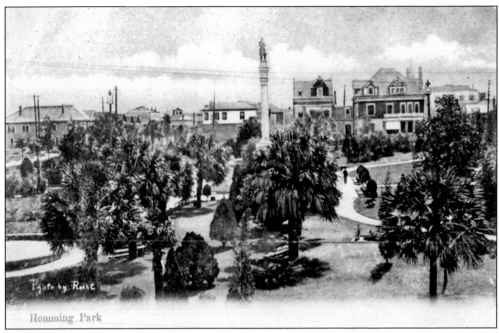

Hemming Park

When the park was first deeded to the city, it did not have a name; it was simply referred to as "City Park." Eventually it became widely known as "St. James Park." Interest in the park grew after the St. James Hotel was completed in 1869, and improvements were made, such as a bandstand and a fence around the park. (O. Rust.)

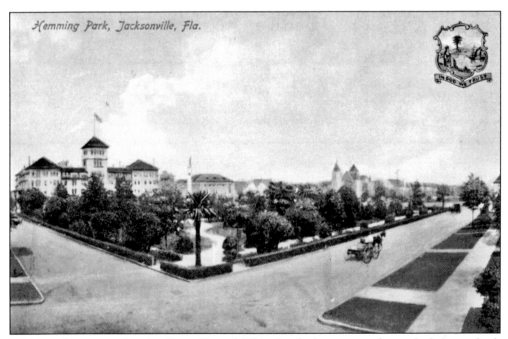

Hemming Park, Jacksonville, Fla.

Within a few years after the Great Fire of 1901, the shady canopy of trees had grown back and the park was once again an oasis in the center of the city. This 1908 postcard shows the southeast corner, where Monroe and Laura Streets intersect. (M. Mark.)

By 1887, the St. James Park was in need of improvements. The city financed the improvements, which included sidewalks, a fountain, and landscaping. Then, in 1898, Charles C. Hemming, a Civil War veteran, donated the Confederate Monument to the city.

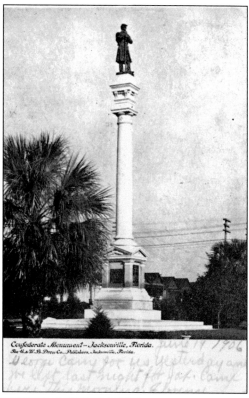

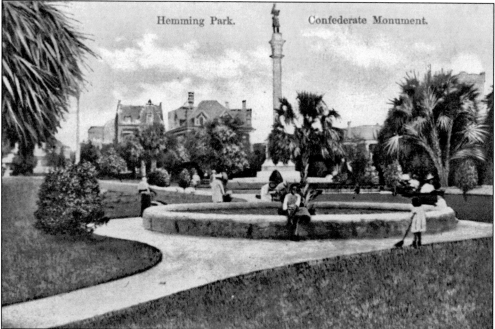

The fountain was originally located in the center of the park. It was moved to the northwest corner in order to make way for the Confederate Monument. The name of the park was officially changed to Hemming Park in 1899. (O. T. Jones.)

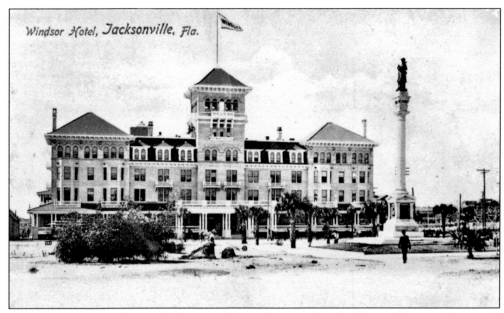

The fire of 1901 also destroyed the original Windsor Hotel. Rebuilding of the Windsor Hotel began four months after the fire and was completed in less than a year. This enormous hotel was located on Hogan Street and stretched from the northwest corner of Monroe Street all the way down to the southwest corner of Duval Street. (National Art Views Company.)

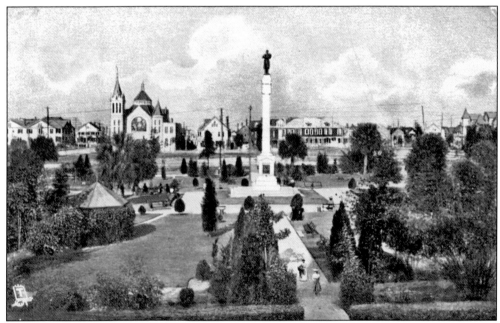

The Confederate Monument is the focal point of this 1910 postcard. Behind the monument is Duval Street, which parallels the north side of the park. The First Baptist Church is located on the northeast corner of Hogan and Church Streets. The famous St. James Hotel sat between Duval and Church Streets until the fire destroyed it in 1901. This lot remained vacant until 1911. (Raphael Tuck and Sons.)

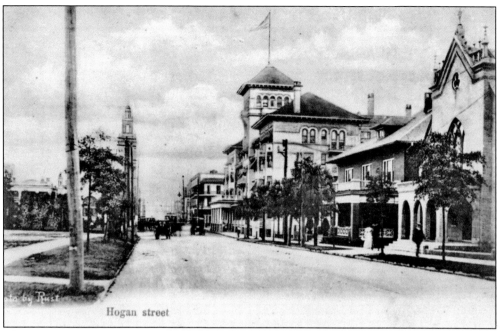

This pre-1907 postcard provides a view of Hogan Street looking south from Church Street. The first building to the far right is the Union Congregational Church of Jacksonville, followed by the Seminole Club. Across Duval Street is the Windsor Hotel. The church and hotel have been demolished. (O. Rust.)

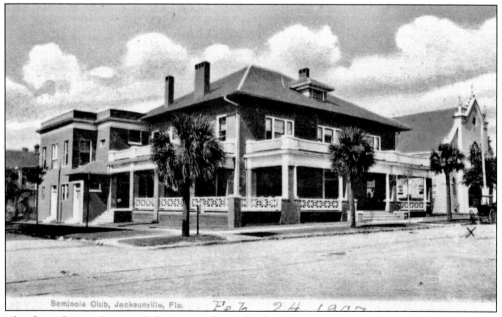

The fire of 1901 destroyed the Seminole Club's building, located on the northeast corner of Main and Forsyth Streets. In 1902, construction was started on a new two-story building on the northwest corner of Hogan and Duval Streets. The building of this former men's club still stands today but has been remodeled and altered numerous times, starting in 1907 when a third story was added. (G. W. Morris.)

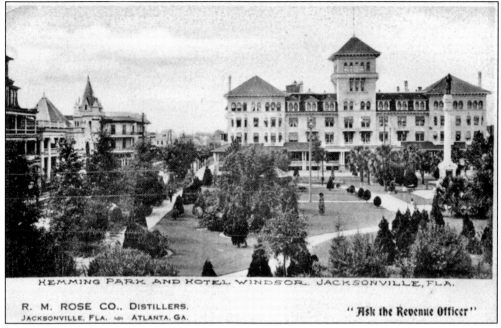

HEMMING PARK AND HOTEL WINDSOR, JACKSONVILLE, FLA.

R. M. ROSE CO., DISTILLERS.
JACKSONVILLE, FLA. ⚬ ATLANTA, GA.

"Ask the Revenue Officer"

Postcards were, and still are, a form of advertisement. R. M. Rose Company prominently displayed its business name on this pre-1907 postcard. Shown is the southwest corner of Hemming Park. (The Albertype Company.)

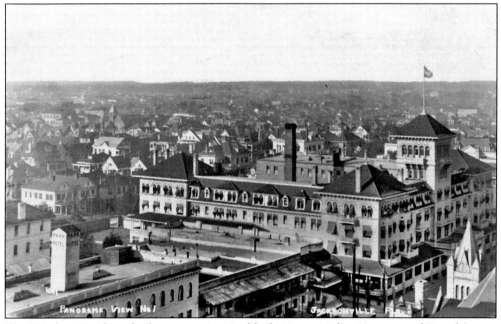

The Windsor Hotel was built on an entire city block. Hogan, Julia, Monroe, and Duval Streets framed it. It was the only large hotel rebuilt after the 1901 fire and had accommodations for 500 guests. This real-photo postcard, dated 1921, provides an aerial view of this sprawling hotel.

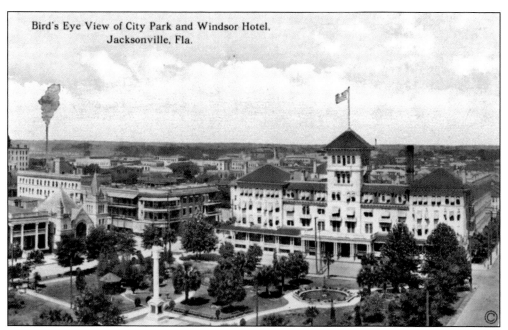

The Windsor Hotel faced the west side of Hemming Park, titled "City Park" on this 1910 postcard. "Curio Row" started at the southwest corner of Hogan and Monroe Streets. The Park Hotel can be seen farther south, on the northwest corner of Adams Street. (H. and W. B. Drew Company.)

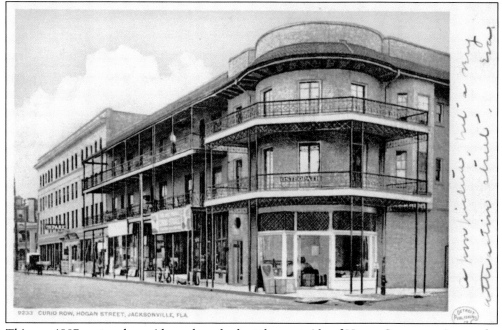

This pre-1907 postcard provides a closer look at the west side of Hogan Street, starting on the southwest corner of Monroe Street and continuing south to the northwest corner of Adams Street. This section of Hogan Street was known as "Curio Row," where hotel guests and tourists could shop for souvenirs. (Detroit Publishing Company.)

The east side of Hogan Street is seen in this pre-1908 postcard. To the far left is the southwest corner of Hemming Park. Across the street, on the southeast corner of Monroe Street, is the 1903 First Christian Church. (M. Mark.)

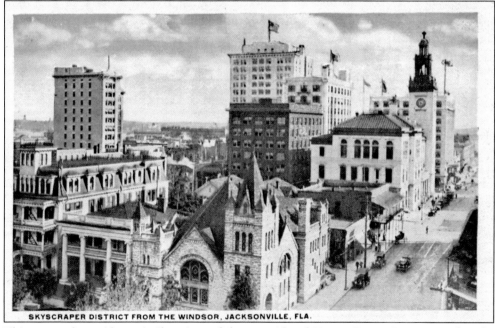

This postcard provides a similar view of the east side of Hogan Street. Documented is the dramatic change that took place between 1908 and 1914, when the first downtown skyscrapers were built. These skyscrapers are the 11-story Florida Life Building (far left), located on Laura Street, and, to the right, the Heard National Bank and the Atlantic National Bank buildings. These two buildings were located on Forsyth Street.

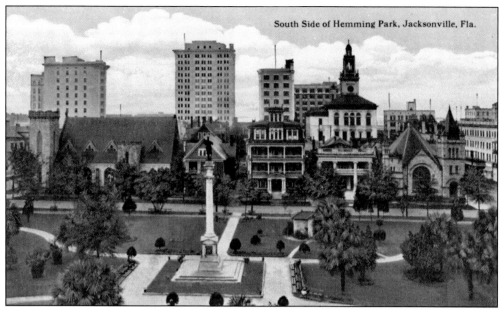

Monroe Street faces the south side of Hemming Park. The Snyder Memorial Methodist Church is located on the corner of Laura and Monroe Streets, on the left side. This building can still be seen today and looks very much as it did in 1903. The First Christian Church was located on the corner of Hogan and Monroe Streets (right). This building was eventually demolished. (H. and W. B. Drew Company.)

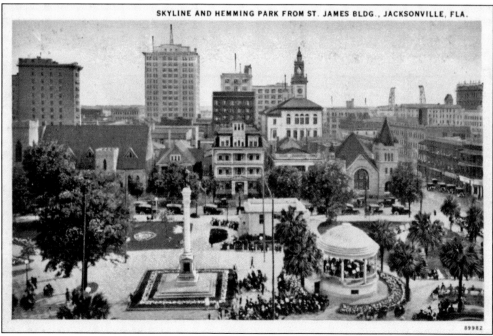

SKYLINE AND HEMMING PARK FROM ST. JAMES BLDG., JACKSONVILLE, FLA.

This postcard shows a similar view of the south side of Hemming Park about one year later. The skyline has not changed, although Hemming Park has: the grass has been removed, the walkways have been widened, and a bandstand has been added. The old YWCA building is also pictured in the center of this postcard, facing the park. (H. and W. B. Drew Company.)

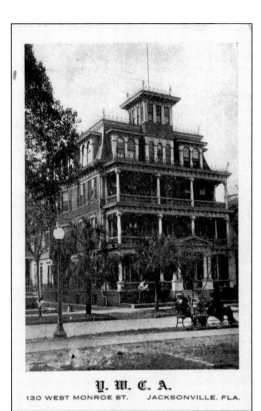

This large residence overlooking Hemming Park was purchased by the YWCA soon after the organization was founded in 1911. It served as the YWCA's headquarters as well as "furnish[ing] a safe and economical boarding home and lunch room for business girls."

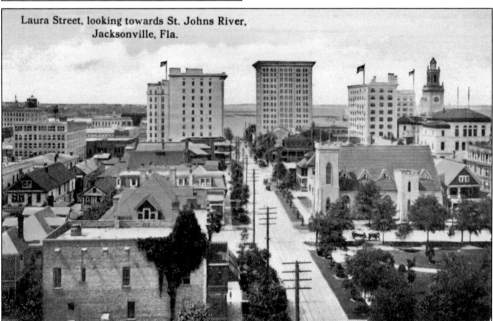

This view from the top of the YMCA Building shows Laura Street looking south toward the St. Johns River. The southeast corner of Hemming Park is on the lower right-hand side, and across Monroe Street is the Snyder Memorial Methodist Church. Jacksonville's first skyscrapers tower over the long-gone residential homes of the downtown area. (H. and W. B. Drew Company.)

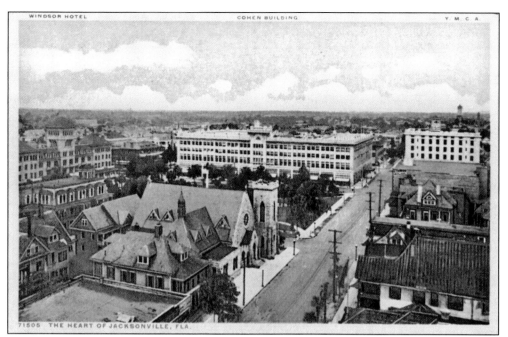

More residential homes can be seen in this aerial view looking north up Laura Street. The Windsor Hotel on the far left side faces the west side of Hemming Park. Cohen Brothers Department Store, located in the St. James Building, is seen in the center facing the north side of the park. (Detroit Publishing Company.)

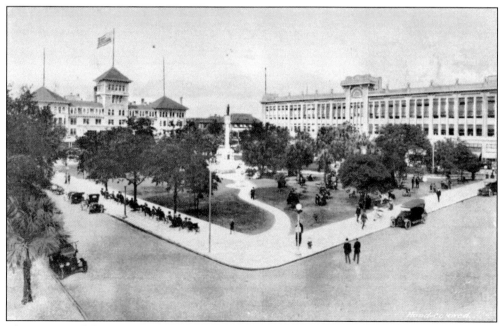

The owners of the newly rebuilt Windsor Hotel purchased the vacant lot that was occupied by the St. James Hotel before it was destroyed by the 1901 fire. They wanted to prevent a rival hotel from building there. The lot was sold in 1910 to Jacob and Morris Cohen with the stipulation that they could not build a hotel at the site.

65

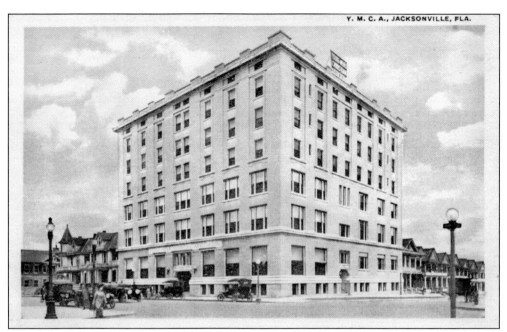

The 1909 YMCA building is located on the northeast corner of Laura and Duval Streets. It was designed by Henry J. Klutho and was Jacksonville's first building designed in the Prairie School style. This building is being renovated and will be used by the city. (H. and W. B. Drew Company.)

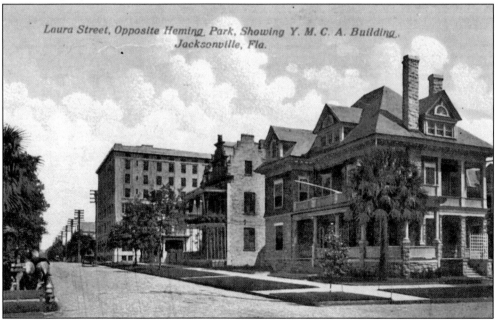

This postcard provides a view of Laura Street looking north from Monroe Street. On the lower left side is the southeast corner of Hemming Park. Featured on this postcard are the buildings that once faced the east side of the park. Today Jacksonville's new Main Public Library is located on this northeast corner of Laura and Monroe Streets. The seven-story YMCA Building is seen in the distance. (H. and W. B. Drew Company.)

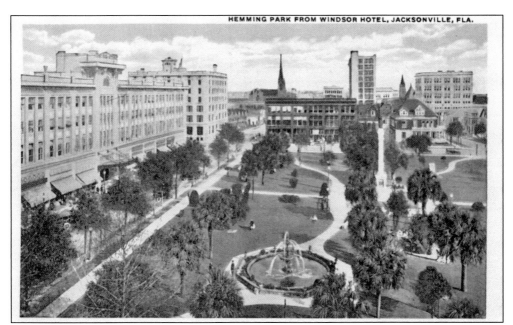

The Cohen brothers commissioned Henry Klutho to design a building for their department store. The brothers agreed to Klutho's plan for a four-story building that covered the entire city block facing the north side of Hemming Park. Klutho was the construction manager for the project, and it was completed in 18 months. The St. James Building, named in honor of the old hotel, was the largest building in Jacksonville when it opened in 1912. (H. and W. B. Drew Company.)

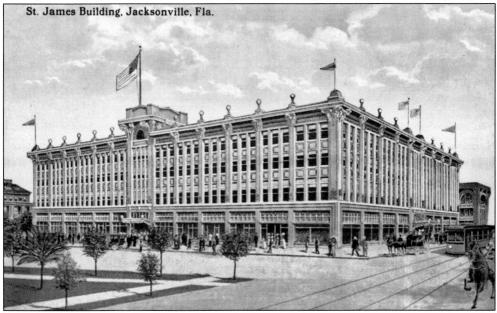

St. James Building, Jacksonville, Fla.

Cohen Brothers Department Store, "The Big Store," filled the center of the first story and the entire second story of the St. James Building. Small private shops were located on the ground-floor periphery, and office space was on the third and fourth floors. This mixed-use design was an innovative concept at the time. Today Jacksonville's city hall is located in this Prairie School masterpiece. (H. and W. B. Drew Company.)

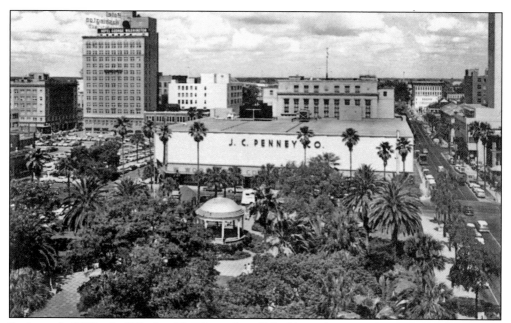

In the early 1950s, the Windsor Hotel was demolished to make room for the F. W. Woolworth and J. C. Penney stores. Curio Row and the Park Hotel were demolished to build a parking lot. Gone is the grass and the church that faced the southwest corner of the park. The park was redesigned into a plaza. This postcard view of Hemming Park and the surrounding area has changed dramatically. (The Duval News Company.)

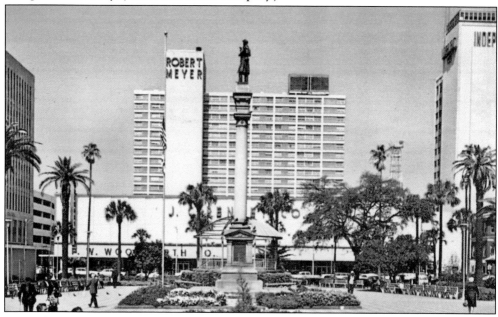

Many downtown businesses, hotels, theaters, and restaurants were segregated, and in 1959, civil rights demonstrations began. Black youths picketed peacefully and took part in lunch counter sit-ins. On August 27, 1960, the peaceful demonstrators were attacked. This violent day, which culminated in Hemming Park, became known as "Axe Handle Saturday." Today this historic park is called Hemming Plaza. (Marsh Post Card Service.)

Five

GOVERNMENT AND PRIVATE BUILDINGS

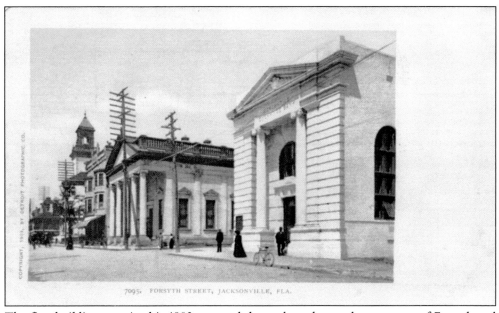

The first building seen in this 1903 postcard, located on the northeast corner of Forsyth and Laura Streets, is the Mercantile Exchange Bank. This neoclassical Revival–style building was built in 1902. Across Laura Street, on the northwest corner, is the National Bank of Jacksonville, and farther down Forsyth Street, one can see the tower of the former post office. (Detroit Photographic Company.)

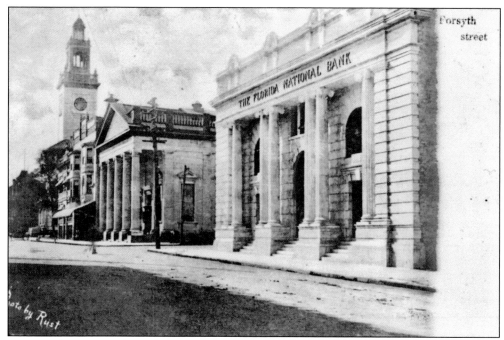

In 1905, the Mercantile Exchange Bank and its building were purchased by the Florida Bank and Trust. By August 9, 1906, the new banking firm had changed its name to the Florida National Bank and expanded the building to double its original size. (O. Rust.)

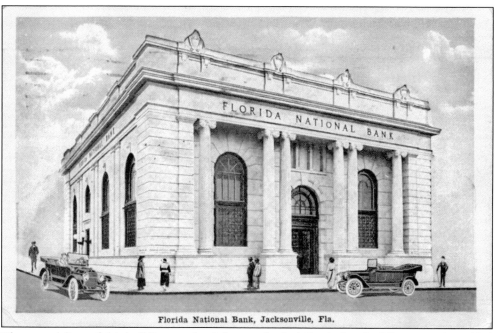

Florida National Bank, Jacksonville, Fla.

The remodeling of this building retained the neoclassical Revival style. The expansion added four additional massive marble columns and retained an entire facade sheathed in marble. (E. C. Kropp Company.)

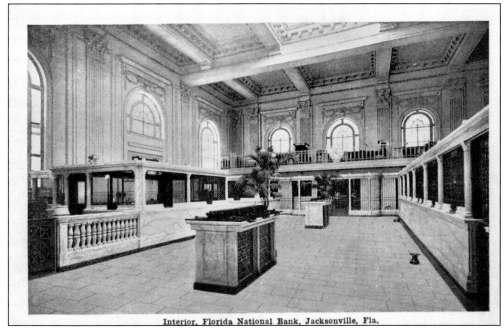

Interior, Florida National Bank, Jacksonville, Fla.

In 1916, the interior of the Florida National Bank Building was completely gutted and redesigned into a grand banking room. The remodeling included a spectacular skylight, coffered ceiling, and classic plaster detailing, all at a cost of $135,000. (E. C. Kropp Company.)

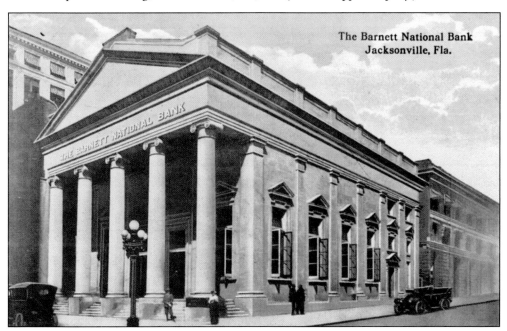

The Barnett National Bank
Jacksonville, Fla.

The Barnett National Bank was originally incorporated in 1877 as the Barnett Bank. On April 14, 1888, the name was changed to National Bank of Jacksonville, and exactly 20 years later, on April 14, 1908, the name was changed to Barnett National Bank. This building was built in 1898 with solid masonry walls and Bedford sandstone at a cost of $30,000. It survived the Great Fire of 1901. (H. and W. B. Drew Company.)

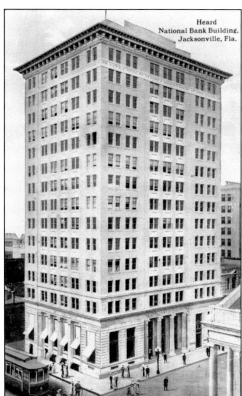

The Heard National Bank opened for business on February 3, 1912. The bank moved into its new 15-story building, located on the southwest corner of Forsyth and Laura Streets, a year later. According to the bank's president, John Joseph Heard, the bank was forced to close on January 16, 1917. Heard paid back 100 percent of the money owed to each depositor. (H. and W. B. Drew Company.)

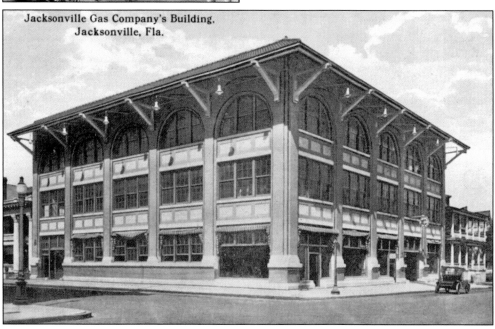

The Jacksonville Gas Company moved into this building in 1913. The building was located on the northwest corner of Laura and Church Streets. The sender of this postcard, dated March 20, 1916, explains what happened to the previous tenant: "This was originally Gilbert's Garage [see page 30], had to hunt smaller quarters." (H. and W. B. Drew Company.)

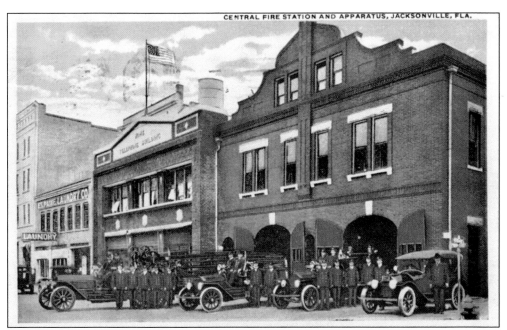

The Central Fire Station was first located on Forsyth Street between Ocean and Newnan Streets. In 1897, it moved to the northwest corner of Ocean and Adams Streets. The building was destroyed in the fire of 1901. It was quickly rebuilt in 1902, and Fire Station No. 1 was back in operation. The original architectural appearance of this building was erased during a remodeling in 1944. To the left of the fire station is the Home Telephone Company Building, designed by Henry J. Klutho in 1913. (H. and W. B. Drew Company.)

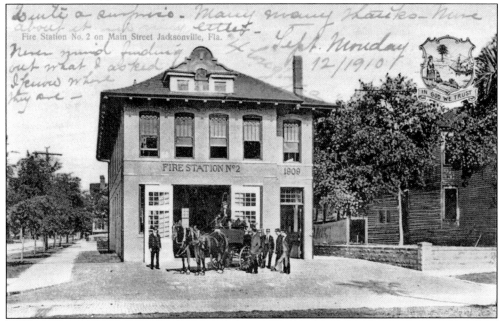

Fire Station No. 2 was built in 1909 in the Springfield neighborhood, on the southeast corner of Fourth and Main Streets. It is the second oldest fire station in Jacksonville and is still in full operation. (M. Mark.)

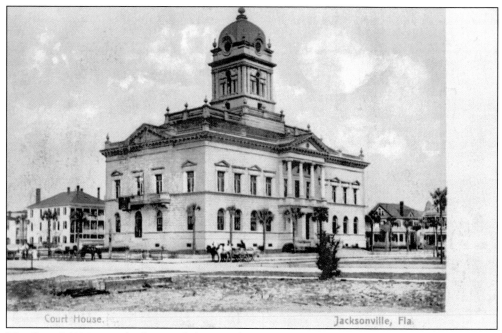

Court House. Jacksonville, Fla.

The fire of 1901 severely damaged the courthouse that was located on the northeast corner of Forsyth and Market Streets. The new Duval County Courthouse was built on the northwest corner of Market and Forsyth Streets, since the county already owned the two lots and more land was needed to accommodate a larger building. (The American News Company.)

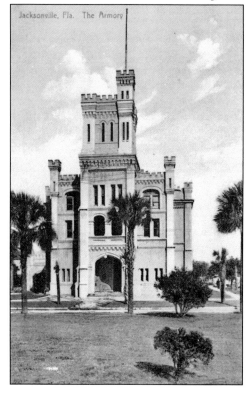

Jacksonville, Fla. The Armory

The armory, located on Market Street, was made from the thick brick walls of the burned-out courthouse. The old bricks were covered with artificial stone, thus retaining the original outline of the previous building except for the clock tower. (The Hugh C. Leighton Company.)

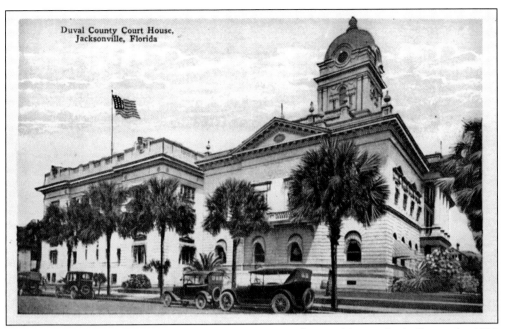

Since more court space was needed by 1914, an annex, designed in a style similar to the 1902 courthouse, was built. It was completed in 1918. The annex is on the left side of this postcard, partially hidden behind the palm trees. In 1960, the courthouse was demolished, and the annex is now the dominating building on East Forsyth Street between Newnan and Market Streets. (The Duval News Company.)

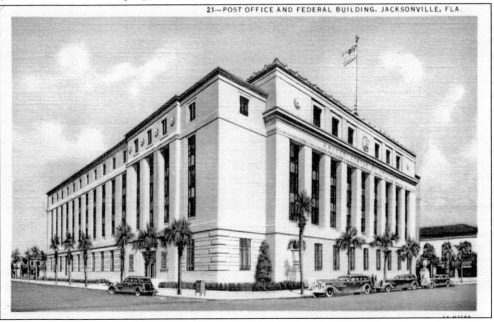

The U.S. Post Office and Courthouse was built in 1933. This massive building is located on Monroe Street between Julia and Pearl Streets. The customhouse and immigration offices were once located in this building. These two offices of service were open Monday through Saturday for official business related to vessels, freight, and passengers. (The Duval News Company.)

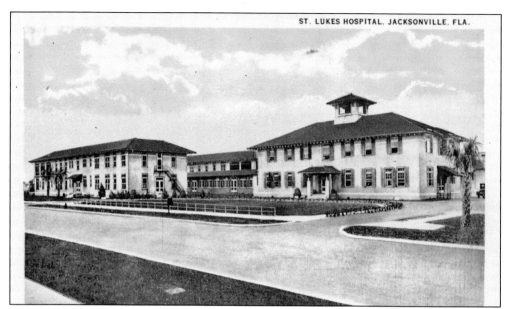

In 1872, a group of women formed the Ladies' Benevolent Society. Its goal was to establish a public facility to help the sick and destitute strangers arriving in Jacksonville, seeking a warmer climate. Within three months, the first St. Luke's Hospital was opened but was lost to fire almost immediately. A new hospital was built in 1878 on the corner of Palmetto and Duval Streets. In 1914, the hospital moved to this larger, new Springfield complex designed by Mellen C. Greeley. (H. and W. B. Drew Company.)

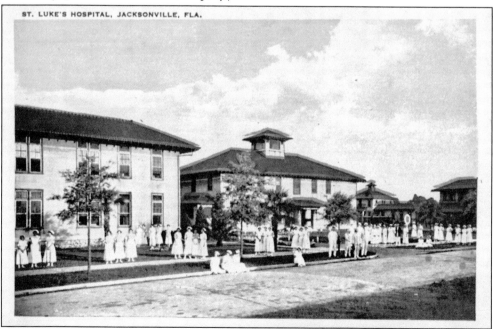

Florida's first modern nursing school was established at St Luke's Hospital in 1885. A new and modern pavilion-style hospital with connecting corridors was built in Springfield in 1914. St. Luke's Hospital was clearly a sign of progress for the city of Jacksonville. (The Duval News Company.)

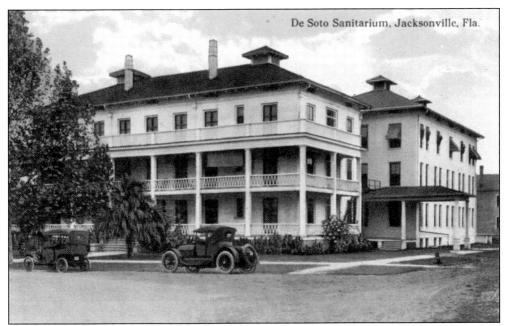

Jacksonville continued to grow, and so did the need for more hospital beds. The De Soto Sanitarium was a new 42-bed hospital in Springfield, located at Fifth and Berry Streets, started by five local physicians in 1906. They were not prepared for hospital administration. As a result, by 1911, the hospital was in financial trouble. The Sisters of Charity purchased the facility in 1916 and renamed it St. Vincent's Hospital. (H. and W. B. Drew Company.)

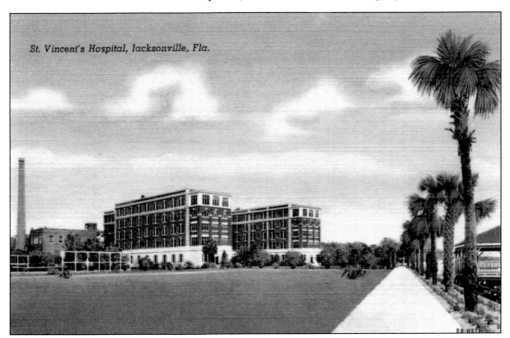

In 1928, patients were transferred from St. Vincent's Hospital in the Springfield neighborhood to the new, $1-million, 200-bed hospital located in the Riverside section on Barrs Street. (The Duval News Company.)

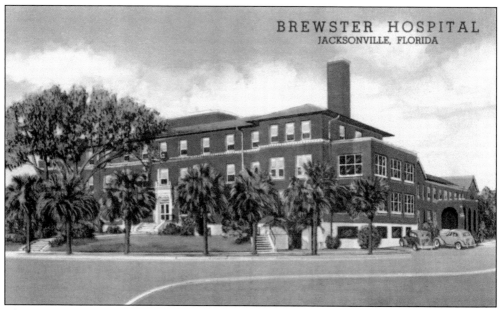

BREWSTER HOSPITAL
JACKSONVILLE, FLORIDA

The Brewster Hospital and Nurse Training School was started in 1901 with a $1,500 gift from Mrs. George A. Brewster. It was the first hospital to employ African American nurses in order to care for blacks in Jacksonville. The Civil Rights Act of 1964 forced the opening of the other city hospitals to the black community. This resulted in loss of revenue and forced the Brewster Hospital to close in 1966.

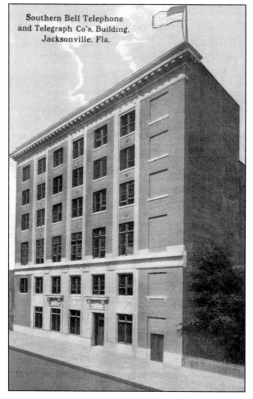

Southern Bell Telephone and Telegraph Co's. Building, Jacksonville, Fla.

The Southern Bell Telephone and Telegraph Company building was built in 1913 to meet the growing demand for modern telephone service. The company, which began service in 1880, had over 750 operators working in this main exchange building by 1960. The building was demolished 40 years later. (H. and W. B. Drew Compa.)

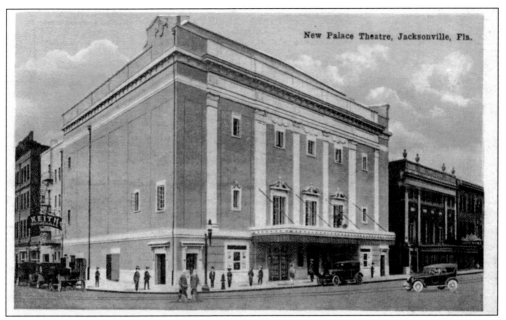

The Palace Theatre opened on April 3, 1919, on the southwest corner of Ocean and Forsyth Streets. Local architect Roy A. Benjamin designed this theater, along with the Imperial, Arcade, and Florida Theatres. The Palace Theatre seated 1,878 and was originally part of the Keith vaudeville circuit. During the 1920s, it was converted into a movie house and then was demolished in 1956. (E. C. Kropp Company.)

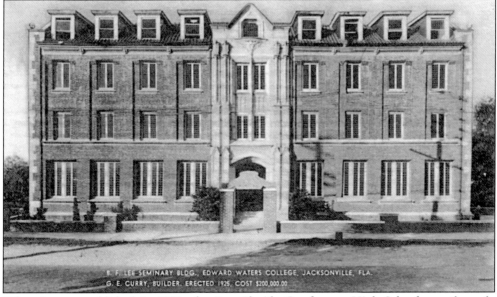

When it was established in 1883, the East Florida Conference High School was the only institute of higher learning for black students. In 1891, it expanded to become a college and was renamed Edward Waters College after the third bishop of the African Methodist Episcopal (AME) Church. The B. F. Lee Seminary Building was constructed in 1925–1927 as a part of the college. This school is Florida's oldest independent institute of higher learning established for the education of African Americans.

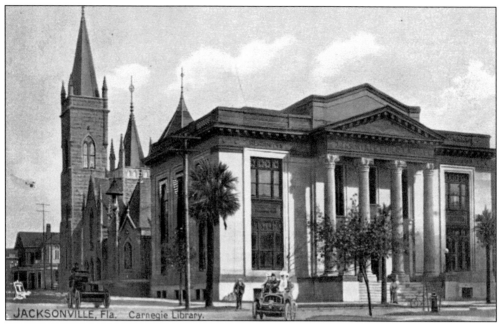

Jacksonville's Free Public Library was open to all citizens, including travelers. A 1929 tourist pamphlet called the "Jacksonville Greeter" states that "the Main Library is open weekdays from 9 a.m. till 9 p.m., and on Sundays from 2 p.m. till 7 p.m. Transients may borrow books by depositing $2.00, to be returned when the borrower leaves the city."

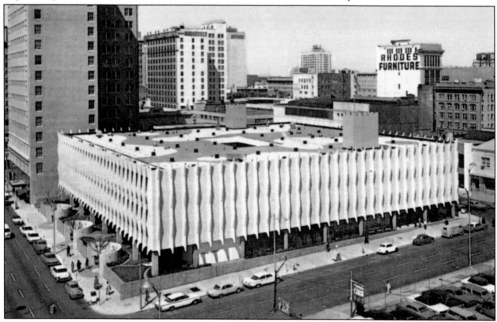

In 1965, Jacksonville's Free Public Library building was closed and replaced with a larger, more modern building. Taylor Hardwick, a local architect, designed the new 126,000-square-foot building. He also specified and designed all interior furnishings, graphics, and bookshelves. Hardwick utilized cheerful colors and natural light. The building was named after the city's former mayor Haydon Burns. (The Duval News Company.)

Six

HOTELS AND MOTELS

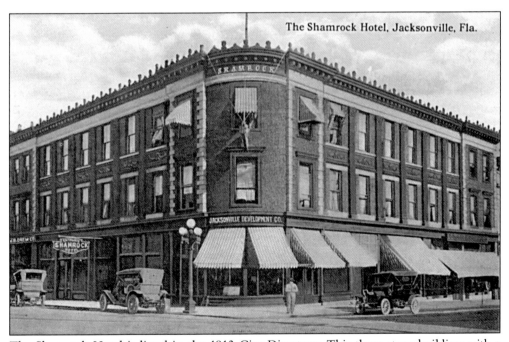

The Shamrock Hotel is listed in the 1913 City Directory. This three-story building with a rounded corner and roof ornaments was located at 52 West Forsyth Street. The Jacksonville Development Company had its sign hanging above the ground-floor window awnings. According to hotel trends of this time period, the hotel rooms were most likely located on the second and third floors. (H. and W. B. Drew Company.)

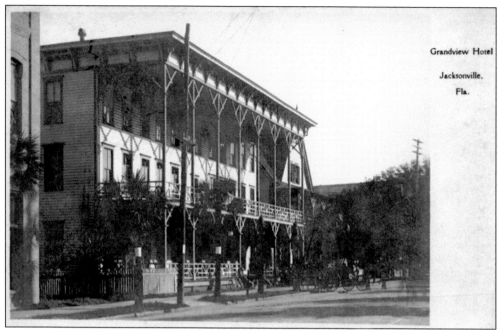

The Grand View Hotel was built in 1883. It was located on the north side of Forsyth Street, between Clay and Broad Streets. The hotel consisted of two buildings, a small building with a gabled roof located on the corner of Forsyth and Clay Streets and a larger three-story building with ornate columns and railings.

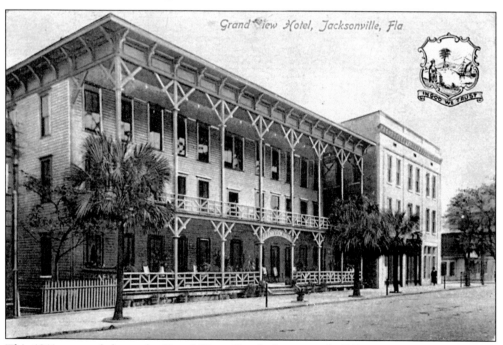

This 1911 postcard shows the Grand View Hotel after a new building was constructed where the smaller corner building once stood. The larger, original building was a wo̶ ̶ ̶ ̶n structure with a decorative Queen Anne–style veranda and balcony. (M. Mark.)

GRAND VIEW HOTEL

Corner Clay and Forsyth Streets

EUROPEAN PLAN

❧ Buffet ❧
Cafe and Pool Rooms

CONNECTING

ROOMS 75c, $1.00 AND UP

D. E. COOPER, Prop.

Hotel Phone 1170. Buffet 961

JACKSONVILLE, FLA.

The Grand View Hotel offered a European plan, which indicated that the quoted rate was strictly for lodging and did not include meals. By the end of World War I, most hotels had changed from an American plan, all meals included, to the European plan.

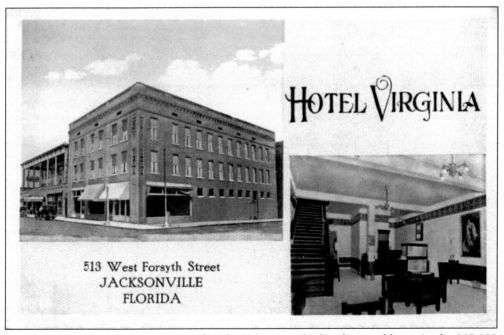

The Grand View Hotel was a tourist hotel until 1910. The hotel was sold, received a $15,000 remodeling, and was reopened as the Hotel Virginia in 1912. This multi-view postcard provides a closer view of the corner building and a glimpse inside the lobby. From 1941 until 1969, the hotel was known as the Gregg Hotel, and by 1974, it was torn down to make space for a parking lot. (Curt Teich and Company.)

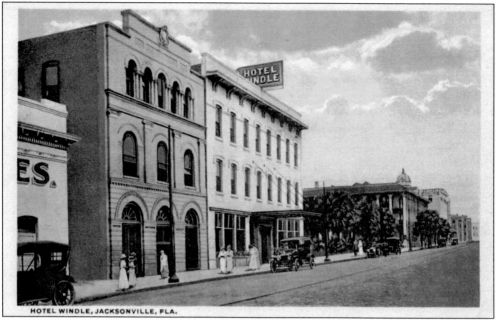

HOTEL WINDLE, JACKSONVILLE, FLA.

The Hotel Windle was located at 17 East Forsyth Street and extended all the way back to Adams Street. It was one of the first hotels of any size to be rebuilt after being destroyed by the Great Fire of 1901. Work on this new hotel started on June 23, 1901. It was opened for business later that same year. (H. and W. B. Drew Company.)

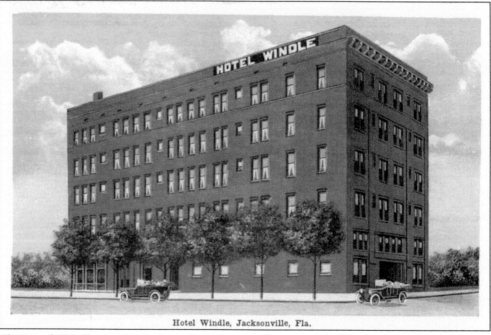

Hotel Windle, Jacksonville, Fla.

The Hotel Windle consisted of two buildings—a three-story building on Forsyth Street and, directly behind it, a six-story building that faced Adams Street. When looking at this postcard, one would assume this building stood alone. Artistic freedom allowed for the removal of all surrounding structures, including the 1902 City Hall Building. (E. C. Kropp Company.)

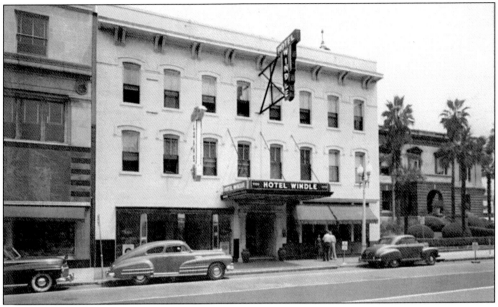

The Hotel Windle was located next to the beautiful grounds of city hall. An old hotel pamphlet states, "The city gardeners strive to outdo the citizens in the production of beautiful palms and flowers. The grounds are tropical with poinsettias and palms." The hotel operated for more than 60 years before being torn down in 1962, along with the 1902 City Hall Building. (Litho, Douglas.)

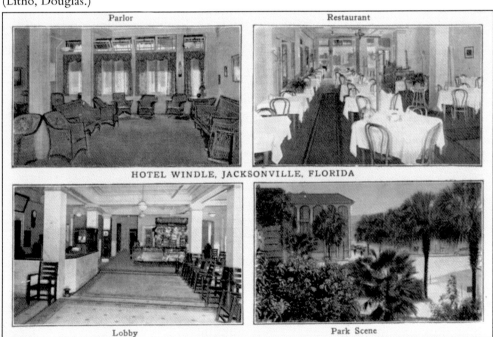

An old hotel pamphlet provided the following description of Hotel Windle: "The Windle Hotel Lobby looks comfortable, homelike, and pleasant. It truly exemplifies the Windle atmosphere." Adjacent to the lobby was the sun parlor, which after a day of sightseeing or shopping provided the most convenient resting spot in the entire hotel. (E. C. Kropp Company.)

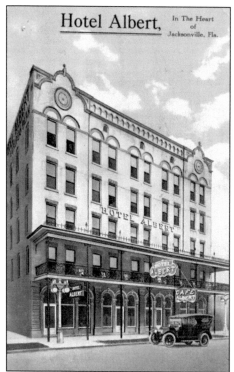

The Hotel Albert, first listed in the 1909 City Directory, was located on the north side of West Adams Street between Laura and Main Streets. The hotel had 100 rooms and provided a European plan. It was in operation until 1928 and advertised itself as "strictly modern." (H. and W. B. Drew Company.)

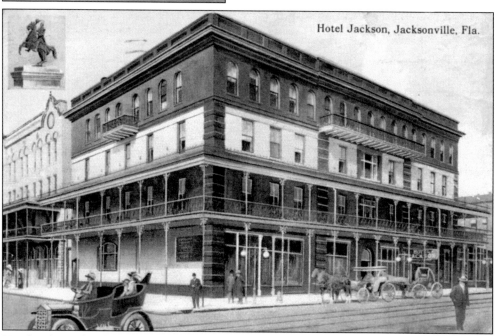

Hotel Jackson, first listed in the 1912 City Directory, was located on the corner of West Adams Street. It advertised itself as "The Perfect Hotel," having received a perfect score of 100 on the Florida Hotel Commission's inspection in 1914. It boasted leather upholstered divans, solid mahogany furniture, brass bedsteads, hot and cold water, electric fans, and an Otis safety elevator. Rooms with a bath were $2.50 to $3 per day. (H. and W. B. Drew Company.)

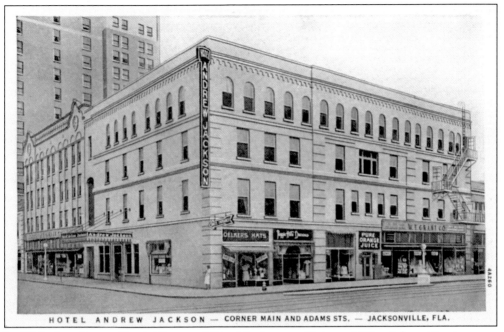

HOTEL ANDREW JACKSON — CORNER MAIN AND ADAMS STS. — JACKSONVILLE, FLA.

In 1929, the adjacent Hotel Albert and Hotel Jackson, at Main and West Adams Streets, came under one ownership. The two buildings were joined and became known as the Hotel Andrew Jackson. (Curt Teich and Company.)

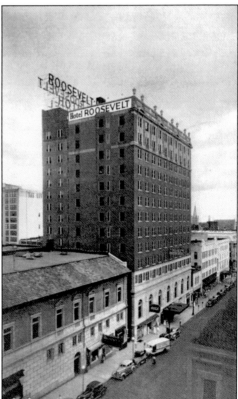

The name of the Carling Hotel, built in 1926, was changed to the Roosevelt Hotel in 1936. The building is still located in the middle of the block on Adams Street between Main and Laura Streets. The hotel closed in 1964, a year after a deadly fire killed 22 guests in the hotel, which was filled with visitors for the annual Gator Bowl game. It operated as a retirement community apartment complex from 1971 until 1987 before sitting vacant for many years. Today an extensive renovation has converted the building for urban living with available retail and office space. A re-creation of the original Carling sign sits high on top of this 13-story building. (Thomsen-Ellis-Hutton Company.)

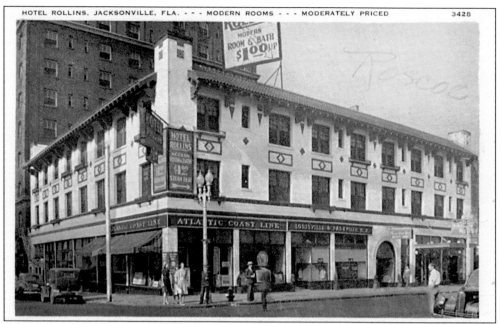

Designed by architects Mark and Sheftall in 1913, this building was originally known as Bachelor Apartments. Located on the corner of Forsyth and Julia Streets, it was next door to the 11-story Mason Hotel, which was built in 1912 and was later known as the Mayflower Hotel. Bachelor Apartments later became the Kyle Hotel and then Hotel Rollins. Both buildings were demolished in the 1970s. (Photo-Color Postcard Company.)

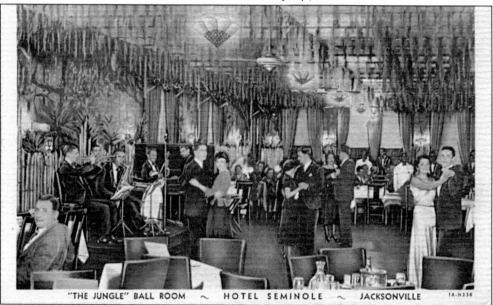

The Seminole Hotel provided popular dining and meeting facilities during the first half of the 20th century. There were two large banquet/meeting rooms: the Grand Ballroom with seating for 400 to 600 persons and the Seminole Room with seating for 250 to 300. Five smaller dining and meeting rooms were also available. This postcard shows the Jungle Ballroom. (Curt Teich and Company.)

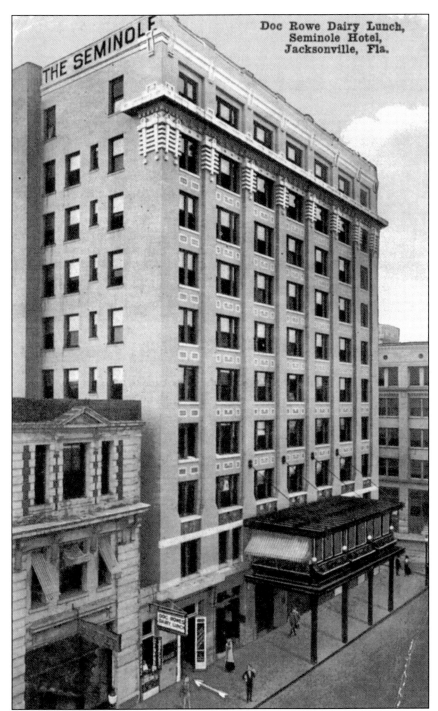

The Seminole Hotel was designed by Henry Klutho and was located at the southeast corner of Forsyth and Hogan Streets. The 10-story building was built in 1909, and the doors opened to the public on January 1, 1910. The Seminole was advertised as Jacksonville's first fireproof hotel. It remained in operation until September 14, 1967. It was eventually demolished in 1974, and today a multi-level parking garage sits on the site of this once-handsome Klutho masterpiece.

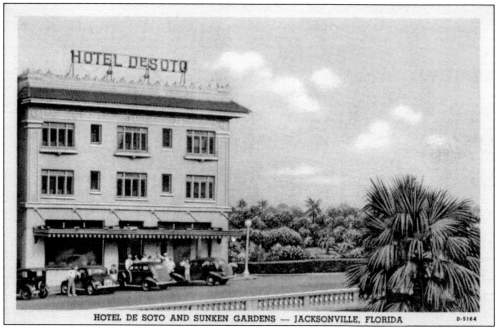

HOTEL DE SOTO AND SUNKEN GARDENS — JACKSONVILLE, FLORIDA

The Hotel De Soto was located at 15 South Lee Street, opposite the Jacksonville Terminal. It was in operation from 1921 until 1966. During the early years, one could get a room with a bath for $2 or $1.50 without a bath. In 1972, the building served as a headquarters for the Northeast Florida Comprehensive Drug Control Program. It was eventually razed in 1977. (Curt Teich and Company.)

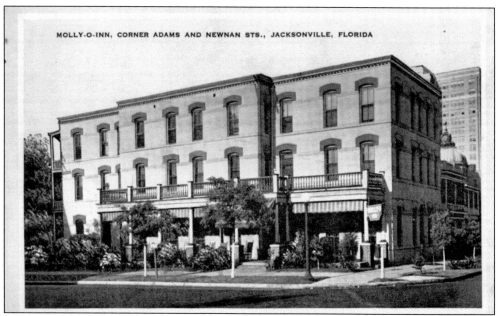

MOLLY-O-INN, CORNER ADAMS AND NEWNAN STS., JACKSONVILLE, FLORIDA

The Molly-O-Inn was built late in 1901 and was located on the southwest corner of Adams and Newnan Streets. It had 35 rooms and a history of many names, including the Manor, the Lenox Hotel, and its final name before meeting the wrecking ball, the Berwood Inn.

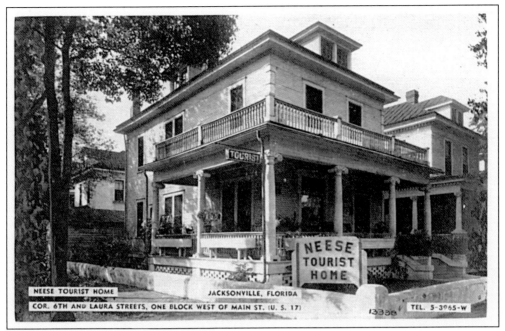

The Neese Tourist Home was located in Springfield on the corner of Sixth and Laura Streets. The proprietors of this private home provided lodging for traveling guests. This tourist home was probably similar to a boarding house, where guests typically shared bathrooms and dining facilities. (Dexter Press.)

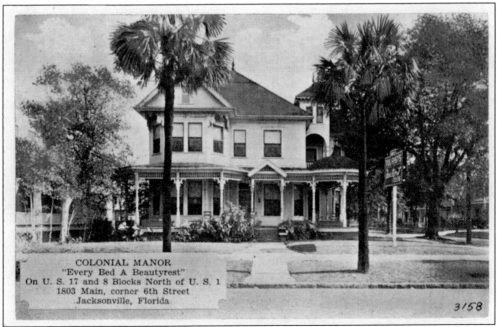

The Colonial Manor was a large home located in Springfield on the corner of Main and Sixth Streets. This establishment provided a home-like atmosphere, which the larger hotels could not match. According to this postcard, guests were sure to get a good night's sleep because every bed had a Beautyrest mattress. (Dexter Press.)

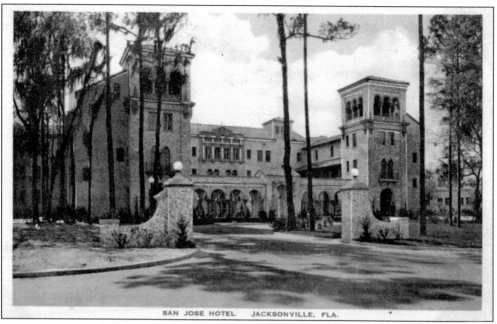

SAN JOSE HOTEL JACKSONVILLE, FLA.

In 1914, Claude Nolan, founder and president of the San Jose Company, was the first to envision a major development four and a half miles south of downtown. Nolan, owner of an automobile dealership, was a strong supporter of better roads and modern transportation. He believed the increasing popularity of the automobile would foster the growth and development of this future suburban community. (The Albertype Company.)

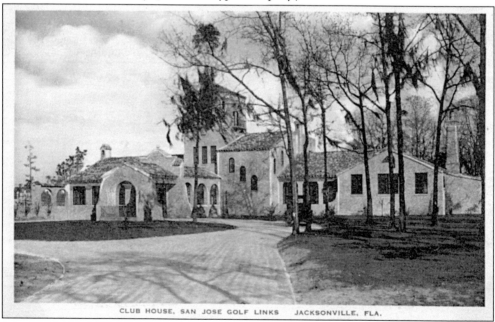

CLUB HOUSE, SAN JOSE GOLF LINKS JACKSONVILLE, FLA.

During the 1920s, the San Jose Estates Company purchased the bulk of the San Jose Company's holdings. It was during this time that this most ambitious real estate development began to take shape. The Mediterranean-style architecture and street names reflected the developments theme, "a bit of Old Spain in the new world." (The Albertype Company.)

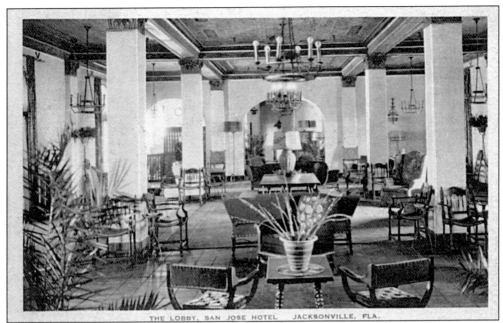

THE LOBBY, SAN JOSE HOTEL JACKSONVILLE, FLA.

The opulent San Jose Hotel opened in January 1926 during the height of the Florida land boom. It was the centerpiece of San Jose development. Envisioned for this planned community were two hotels, a golf course and country club, a promenade along the river, a yacht club, parks, swimming pool, two schools, a shopping center, utilities, and hundreds of homes. (The Albertype Company.)

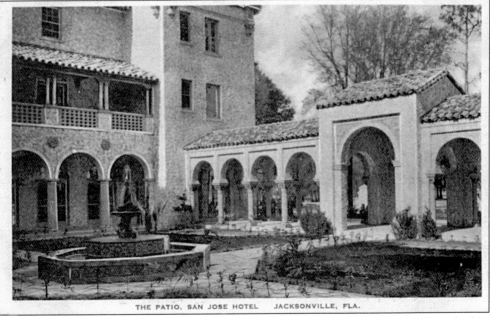

THE PATIO, SAN JOSE HOTEL JACKSONVILLE, FLA.

By 1928, the Florida land boom was over, and the San Jose Hotel was closed. A total of 31 homes had been built by the San Jose Estates Company. The administration building is now the San Jose Episcopal Church, the clubhouse and golf course make up the San Jose Country Club, and the hotel is home to the private Bolles School. (The Albertype Company.)

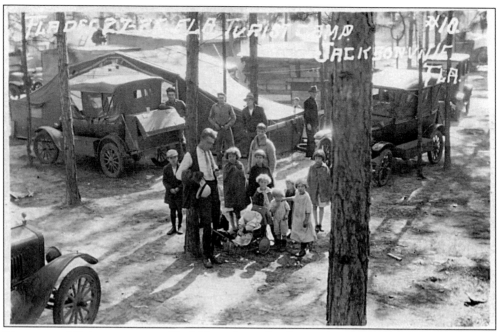

The automobile became more affordable and popular during the 1920s. Roads were primitive, and so was most of the lodging. The first form of lodging available to people traveling by automobile was the simple campground. These campgrounds usually provided tents or cabins and nearby parking spaces. The term "tourist camp" was first used in 1923.

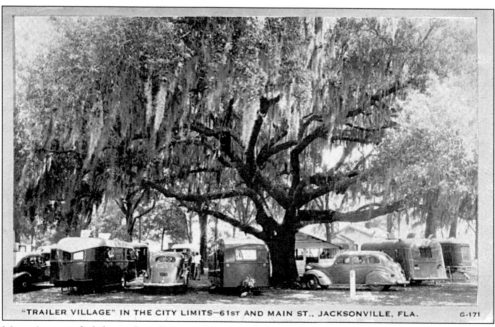

"TRAILER VILLAGE" IN THE CITY LIMITS—61st AND MAIN ST., JACKSONVILLE, FLA. G-171

Motorists traveled through and across the state of Florida, sometimes with their lodging towed behind them. Trailer villages and campgrounds were the resting spots for these travelers. Many guests would return year after year, while others never left, making Florida their home state.

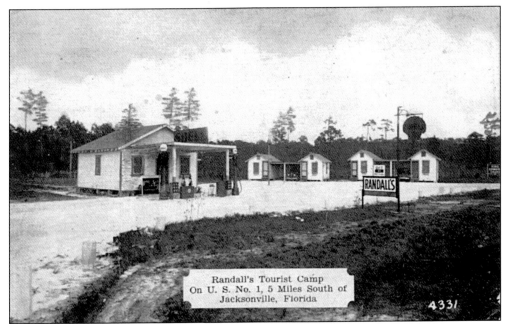

Randall's Tourist Camp
On U. S. No. 1, 5 Miles South of
Jacksonville, Florida

4331

Travel facilities that met the needs of travelers began appearing along roadways. Randall's Tourist Camp provided cabins and a Shell gas station. Covered garages were conveniently connected to each of the cabins. This postcard shows how the automobile was a significant factor in the development of motels. (Silvercraft-Dexter Press.)

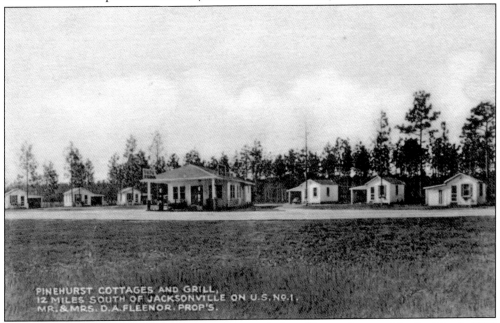

PINEHURST COTTAGES AND GRILL,
12 MILES SOUTH OF JACKSONVILLE ON U.S. No.1,
MR. & MRS. D. A. FLEENOR, PROP'S.

The term "motel" (a combination of "motor" and "hotel") was first used in the March 1925 issue of *Hotel Monthly*. Many different names were used to describe the lodging facilities along the roadway. Their names often reflected their character, amenities, and landscape. Pinehurst Cottages was located under the pine trees and had a "grill" for hungry travelers. (The Cellotype Company.)

95

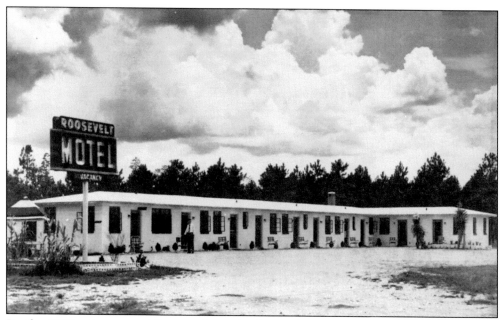

By the 1950s, the automobile was the main form of transportation in the United States. Eventually the name motel was used to describe the vast assortment of lodging available to auto travelers. Originally motels consisted of separate or attached roadside cabins built near large highways, just as hotels had been built near railroad stations.

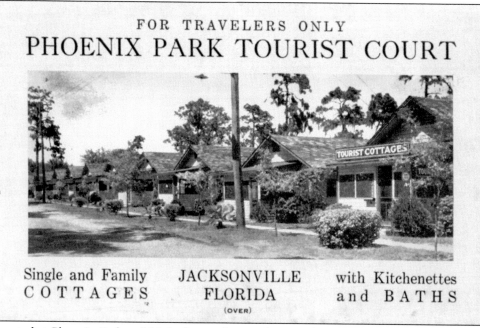

FOR TRAVELERS ONLY

PHOENIX PARK TOURIST COURT

Single and Family JACKSONVILLE with Kitchenettes
C O T T A G E S FLORIDA a n d B A T H S
(OVER)

Located at Phoenix Park and Main Street, three miles outside of the Jacksonville city limits, was the Phoenix Park Tourist Court. It was privately owned and operated under the supervision of the State Board of Health. This tourist camp could be reached by taking the Phoenix Park trolley car or one's personal automobile. The term "tourist court" came into use in 1937.

Seven

RESTAURANTS

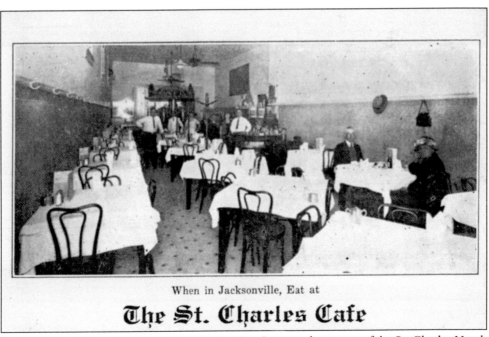

When in Jacksonville, Eat at
The St. Charles Cafe

The St. Charles Café was located at 940 West Bay Street and was part of the St. Charles Hotel. In addition to this restaurant, the hotel had 40 rooms and provided the European plan.

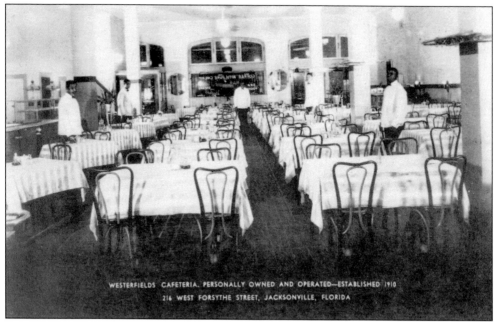

The Westerfield Cafeteria was a family-operated restaurant that was established in 1910. It was located at this Forsyth Street address from 1922 until 1937.

This postcard provides an inviting interior view of the Atlas Restaurant. This long-standing establishment was located at 318 Main Street. The restaurant was in operation from 1922 until 1955. Known for its consistently good food and service, the restaurant stayed in ·iness for 33 years. (E. C. Kropp Company.)

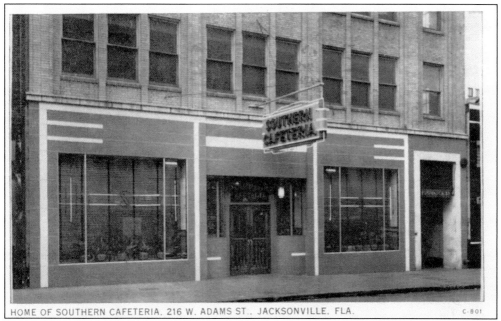

The Southern Cafeteria was located in the Exchange Building on West Adams Street between Hogan and Julia Streets. The restaurant served "Southern Food at its Best," according to this 1941 advertising postcard. The cafeteria was a favorite eating establishment for Southerners, especially after Sunday church. (Wayne Printing Company.)

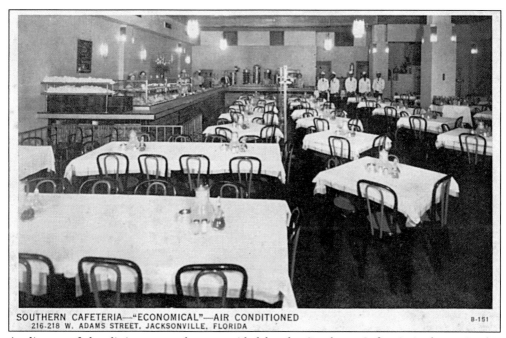

A glimpse of the dining atmosphere provided by the Southern Cafeteria is shown in this postcard. This downtown eatery was conveniently located near the financial district and numerous hotels. (Wayne Printing Company.)

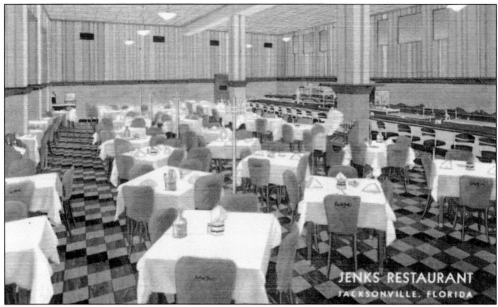

Thomas W. Jenks moved to Jacksonville in order to escape the Canadian winters. In 1911, Thomas Jenks and Harry Howell formed the Jenks Howell Restaurant. Eventually they dissolved their partnership and each opened their own restaurant. Jenks purchased and remodeled the old Board of Trade Building. The restaurant reopened in the early 1930s. Jenks' was the local gathering place for important political and civic leaders. (Genuine Curteich-Chicago.)

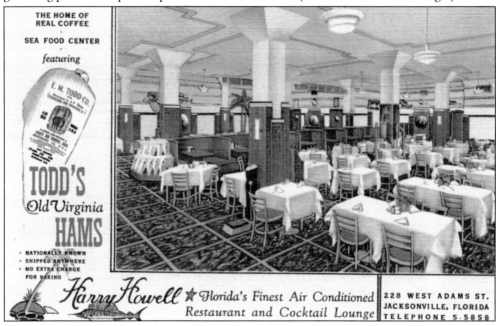

Harry Howell was a major-league pitcher from 1898 until 1910 and entered the restaurant business after his baseball career ended. He first partnered with Thomas Jenks but eventually opened his own restaurant. Harry Howell's Restaurant and Cocktail Lounge was located at 228 West Adams Street. According to this advertising postcard, the restaurant was "The Home of Real Coffee" and a "Sea Food Center." (Genuine Curteich-Chicago.)

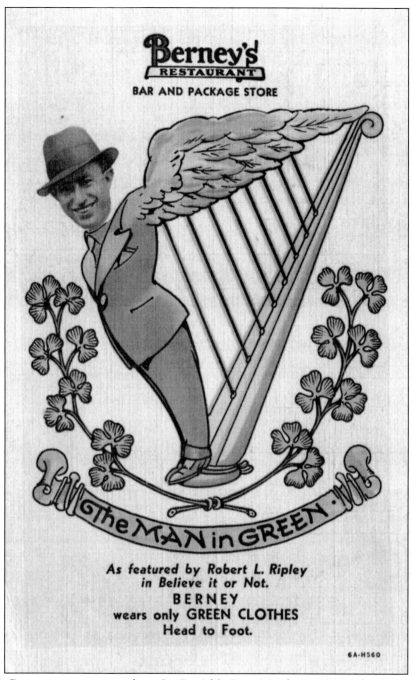

Berney's Restaurant was opened on St. Patrick's Day, March 17, 1927. The green-themed restaurant was located downtown on West Adams Street in the Elks Club Building. Bernard Berney, the "Man in Green," always wore green, and almost everything in his restaurant was green. His philosophy of hospitality was give them the best food and make them feel like they're home. Berney would also instruct his employees, "Never turn down anybody who's hungry. Some people will pay you back; some won't. Help them anyway, you may be hungry yourself someday." (Curt Teich and Company.)

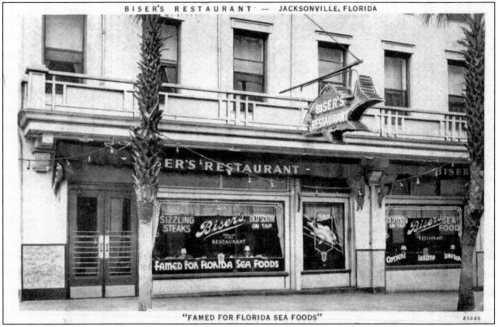

"FAMED FOR FLORIDA SEA FOODS"

Howard Biser's Restaurant was located at 211 West Forsyth Street. The restaurant operated in this building from 1935 until 1939. They served Old South Ale on tap and claimed to have "the best cup of coffee in the state of Florida." (Curt Teich and Company.)

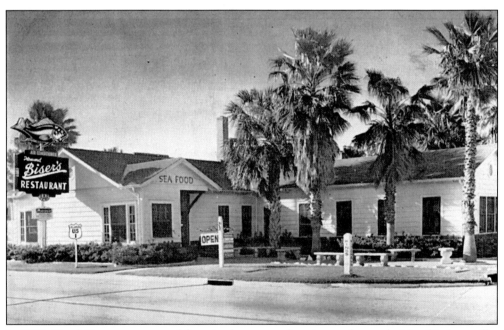

In 1940, Biser's Restaurant moved from its downtown location to the south side of Jacksonville. The new restaurant was located one mile south of the St. Johns River Bridge, now called the Acosta Bridge. Howard Biser's Restaurant was "Famed for Florida sea foods cooked by old Southern recipes, which preserve the tang of the sea and satisfy the appetite." (Curt Teich and Company.)

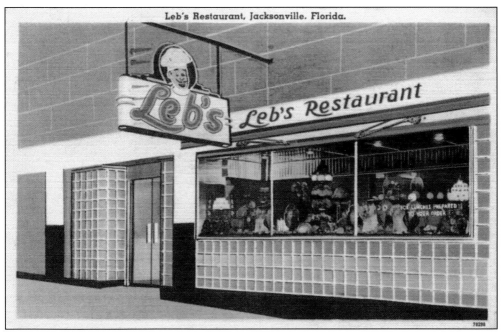

Leb's was a small downtown restaurant located in the Hotel Roosevelt building. It was opened in 1946 and was a fine establishment for before or after theater parties. Leb's provided unusual sandwiches on twin rolls, famous dinner specials, and excellent pastries. It was a sad day when the popular downtown eatery closed in 1969. (Eisner Anderson.)

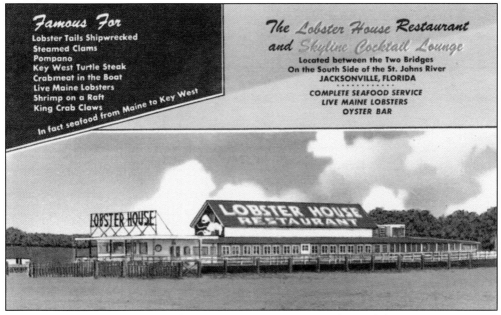

The Lobster House was located between the Main Street Bridge and the Acosta Bridge, on the south bank of the St. Johns River. It was identified as the restaurant "located between the two bridges." After dinner, one could go to the Skyline Lounge for cocktails and dancing and then to the Skylight Deck to listen to the music of Dick Pollock's Candle Lighters. (Sutherlin Sales Company.)

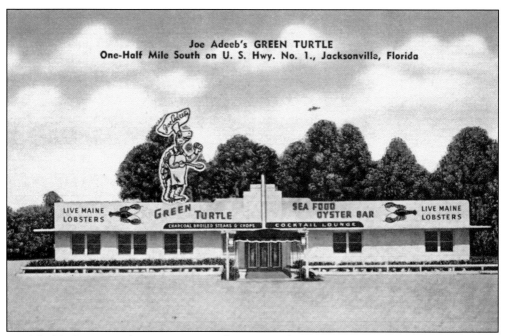

Joe Adeeb's Green Turtle Restaurant was located on the south side of the St. Johns River, half a mile south of the city limits on U.S. Highway 1. Besides dining on Maine lobsters and other seafood, there was dancing. (E. C. Kropp Company.)

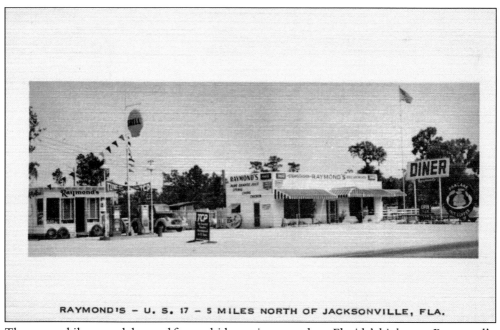

The automobile created the need for roadside service stops along Florida's highways. Raymond's, a convenient gas station and roadside café, provided fuel and food for those traveling along U.S. Highway 17. (National Press, Inc.)

Eight

RETAIL AND SERVICES

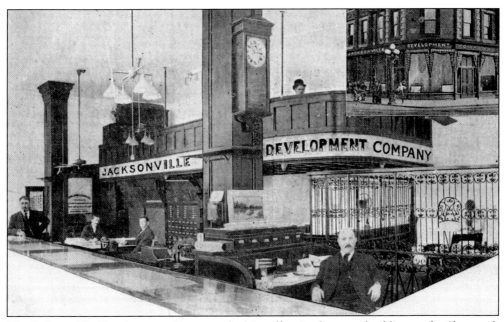

The Jacksonville Development Company had its office in the same building as the Shamrock Hotel, located on Forsyth Street. This company was active in the development of outlying subdivisions, including Murray Hill Heights.

Real estate companies bought and sold city property, suburban property, and farmland, and many times they offered mortgages.

Land was plenty, and Northerners were attracted to the abundant real estate investments. This was often the reason for a Southern relocation.

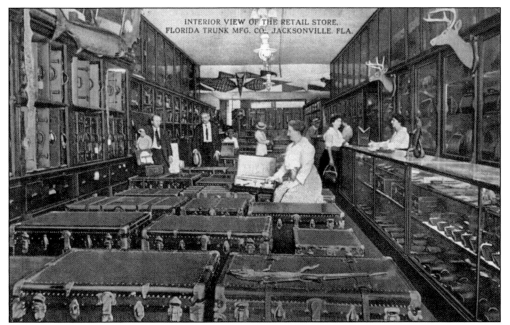

This advertising postcard shows the Florida Trunk Manufacturing Company. Proprietor S. H. Etter sold fancy leather and alligator goods. A traveler could find trunks and bags of all styles made of fine leather. This establishment was located at 118 Main Street during the early 1900s.

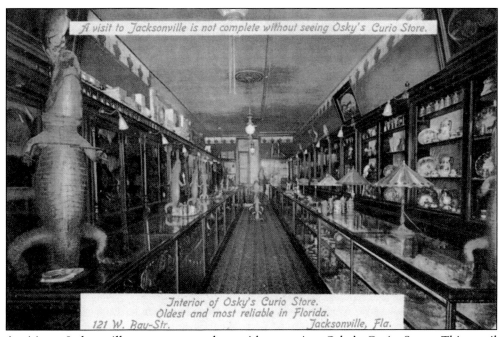

A visit to Jacksonville was not complete without seeing Osky's Curio Store. This retail establishment claimed to be the oldest and most reliable curio store in Florida. It was located on West Bay Street during the early 1900s. (J. Osky.)

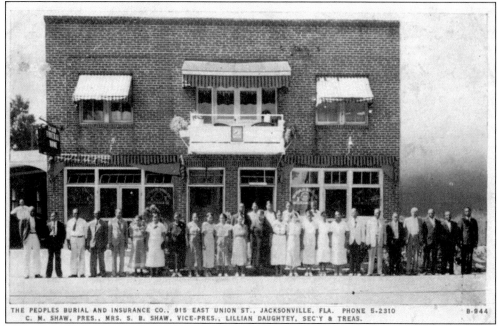

THE PEOPLES BURIAL AND INSURANCE CO., 915 EAST UNION ST., JACKSONVILLE, FLA. PHONE 5-2310 B-944
C. M. SHAW, PRES., MRS. S. B. SHAW, VICE-PRES., LILLIAN DAUGHTEY, SEC'Y & TREAS.

Advertising postcards were issued by service-oriented businesses, such as Peoples Burial and Insurance Company, located at 915 East Union Street during the 1930s and 1940s. It provided burial, life, health, and accident insurance. They were also licensed funeral directors and embalmers. (R. W. Shannon.)

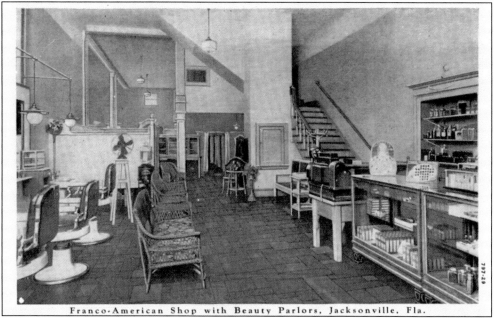

Franco-American Shop with Beauty Parlors, Jacksonville, Fla.

The Franco-American Shop with Beauty Parlors was first located on Laura Street during the 1920s but by 1929 had moved to 29–31 West Monroe Street. Beauty services were provided through the 1950s at this location. "Best in Equipment, Skill and Service" is advertised on the back of this postcard. (Curt Teich and Company.)

108

Harvey's, Inc., was a men's store that sold clothing, furnishings, and hats. It was located at 24 West Forsyth Street. This classy men's shop was in business from 1919 until 1923. In 1924, the Smart Set Hosiery Shop moved in, and by 1925, a luggage shop had taken over. (Curt Teich and Company.)

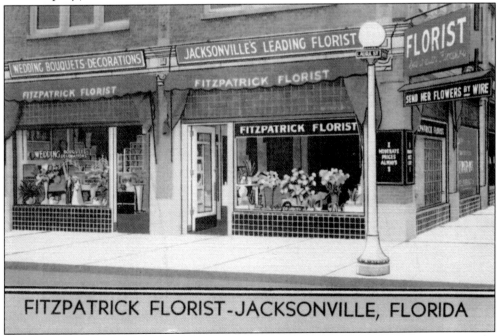

FITZPATRICK FLORIST-JACKSONVILLE, FLORIDA

In 1927, Fitzpatrick and Larson Florists, Inc., was located at 25 West Adams Street next to the Carling Hotel. By 1929, Larson was out and the business was known as Fitzpatrick Florist. The shop moved in 1931 to Laura Street on the corner of Ashley Street. This postcard was used as an acknowledgment of a customer's order. (MWM.)

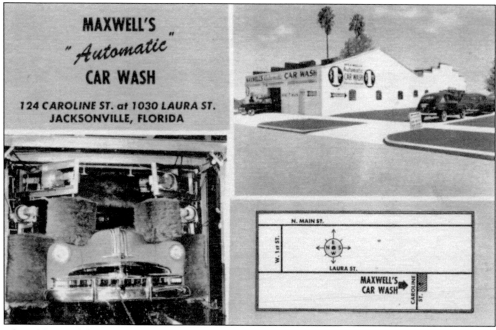

The address of this building first appears in the 1946 City Directory under the name Gorman Motors Auto Repair Shop. This building has been the location of many automobile-oriented businesses, such as Mint Man Car Wash and Auto Glass Company.

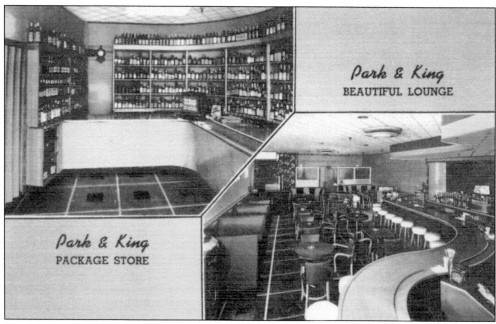

The Park and King Package House and Liquors was first listed at 2710 Park Street in the 1944 City Directory. This business establishment remained in operation until 1972.

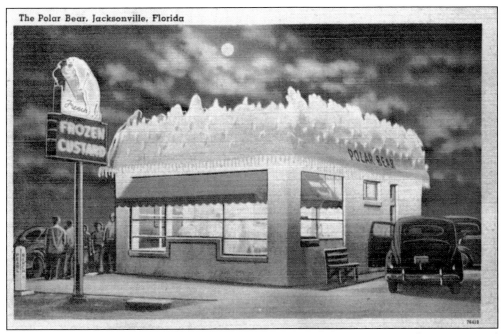

The Polar Bear, located at 3802 Pearl Street, sold tasty, frozen custard treats from 1950 until 1956. A second location was opened on Hershel Street in 1956.

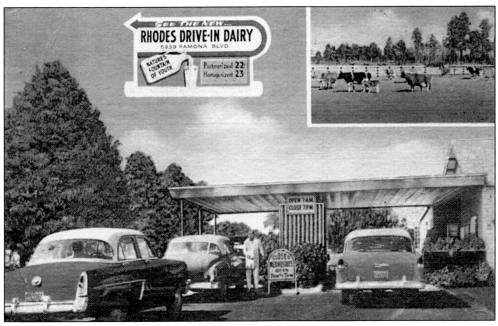

This 1960s postcard of Rhodes Drive-In Dairy is an example of how the automobile influenced retail transactions in everyday life. The drive-through was born.

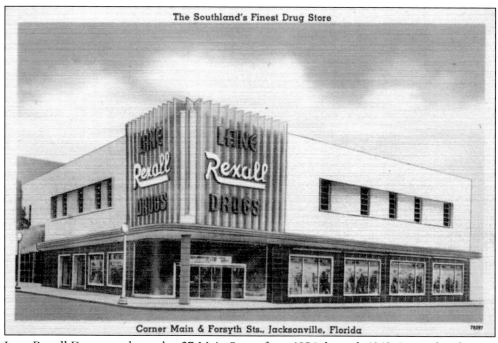

Corner Main & Forsyth Sts., Jacksonville, Florida

Lane Rexall Drugs was located at 27 Main Street from 1956 through 1962. It was then known by the parent company name, Liggett Rexall, until 1972.

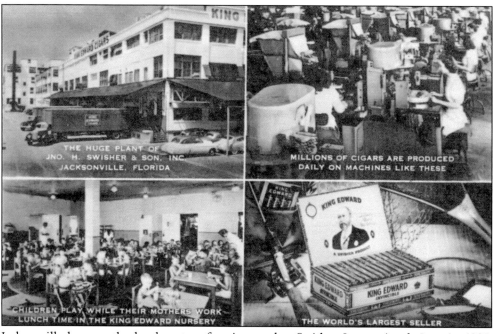

THE HUGE PLANT OF JNO. H. SWISHER & SON. INC. JACKSONVILLE, FLORIDA

MILLIONS OF CIGARS ARE PRODUCED DAILY ON MACHINES LIKE THESE

CHILDREN PLAY WHILE THEIR MOTHERS WORK LUNCH TIME IN THE KING EDWARD NURSERY

THE WORLD'S LARGEST SELLER

Jacksonville became the headquarters for cigar maker Swisher International, Inc., in 1927. This innovative company transformed the cigar industry. They used tobacco-rolling machines, wrapped individual cigars in cellophane, and created pulling tabs for easy removal of the wrappers. Today this Jacksonville facility is the world's largest cigar factory, where Swisher makes more than 11 million cigars per day.

Nine

TOURIST ATTRACTIONS

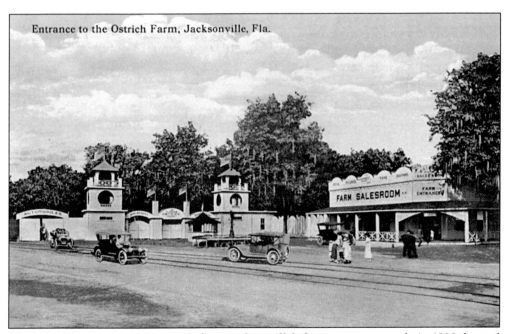

Entrance to the Ostrich Farm, Jacksonville, Fla.

Charles D. Fraser opened an ostrich farm, Jacksonville's first amusement park, in 1898, located in the city's Fairfield neighborhood on the east side of downtown. The ostrich farm moved to Phoenix Park in 1912 and was called the New Ostrich Farm, Amusement Park and Zoo. Tourists could easily reach the park by trolley car or a drive down Talleyrand Avenue. (H. and W. B. Drew Company.)

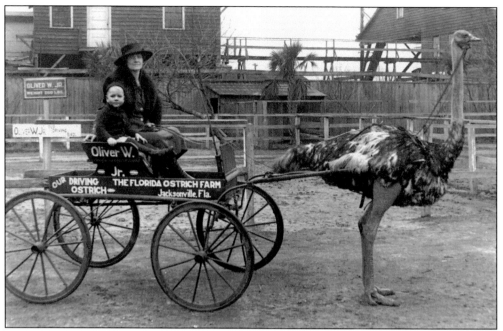

There were ostrich rides and ostrich races at the ostrich farm. Featured were racing ostriches that pulled drivers in sulkies, and "Oliver W." was the famous racing bird. Souvenir postcards documented a tourist's visit to the park.

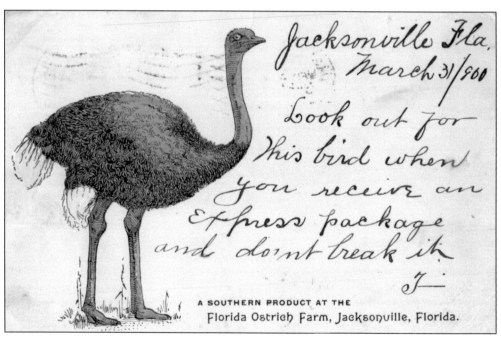

This private mailing card is dated March 31, 1900. The sender of this postcard jokingly writes, "Look out for this bird when you receive an express package and don't break it."

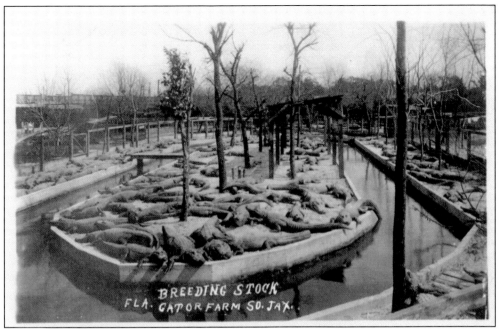

The Florida Alligator Farm was established by Joseph "Alligator Joe" Campbell in 1891. This park was located on the south side of Jacksonville across the river from downtown. This postcard depicts a bunch of lazy alligators sunning themselves; however, many other postcards show very lively alligators putting on shows for the tourists.

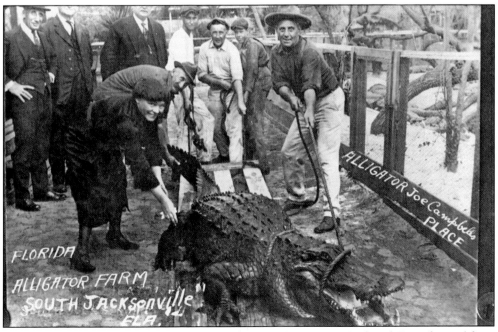

In about 1916, Charles D. Fraser's New Ostrich Farm, Amusement Park and Zoo relocated from Phoenix Park and merged with Alligator Joe's Florida Alligator Farm in South Jacksonville next to the old Dixieland Park, which was renamed Southland Amusement Park.

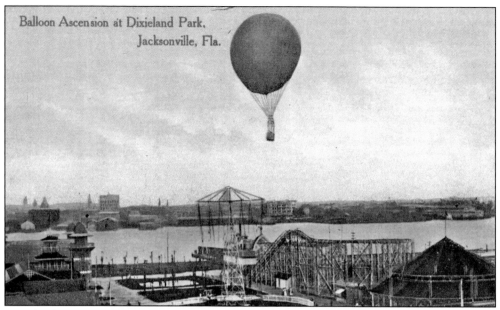

Dixieland Amusement Park opened on March 9, 1907, along the riverfront of South Jacksonville. The Flying Jenny merry-go-round, a 160-foot roller coaster, and a tower with a circular swing ride were the main attractions at the park. It was known as the "Coney Island of the South." (J. S. Pinkussohn Cigar Company.)

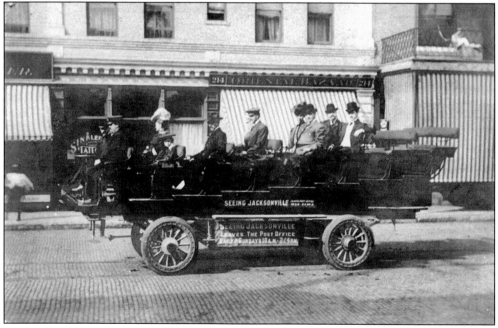

Lectured sightseeing tours were conducted throughout the city. Tourists could comfortably see and learn about Jacksonville's beautiful residential districts and suburbs, parks, and public buildings. Souvenir postcards documented a person's participation in the sightseeing excursions. Tourist photographer J. A. Hollingsworth took this photograph.

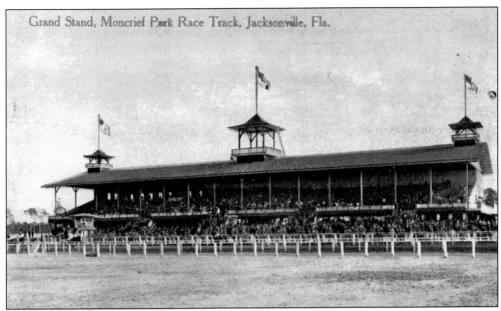

Grand Stand, Moncrief Park Race Track, Jacksonville, Fla.

The first racetrack in Jacksonville was located at the fairgrounds in the eastern suburb of Fairfield. A large, oval racetrack was built on the grounds, even though horse racing was banned until 1884. Professional horse racing made a brief resurgence in 1909 with the opening of Montcrief Race Track in north Jacksonville. The races were held during the tourist season when the hotels were filled. (J. S. Pinkussohn Cigar Company.)

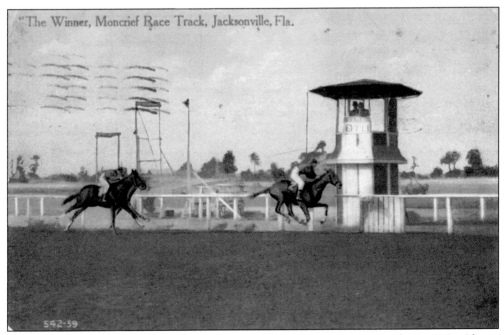

"The Winner, Moncrief Race Track, Jacksonville, Fla.

The horse races gave rise to gambling, which created a public outcry against the sport. Residents, including women, were tempted to "play the ponies." After only two years in operation, the Montcrief Race Track closed following the banning of horse racing by the legislature. A week later, the racetrack burned. Arson was suspected. (J. S. Pinkussohn Cigar Company.)

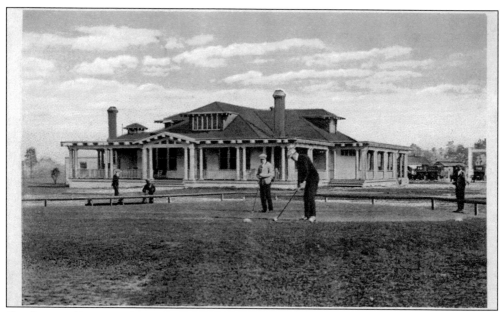

On August 28, 1919, during a luncheon of the Jacksonville Real Estate Exchange, it was determined that a municipally owned golf course was needed. Eventually the city purchased 146 acres of wild land near the state fairgrounds at Golfair Boulevard and Montcrief Road. The golf course was cleared by city prisoners from the prison farm and designed by Donald Ross. The 18-hole course was officially opened on November 8, 1923. (H. and W. B. Drew Company.)

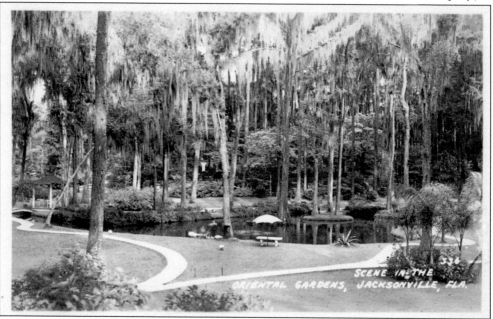

Oriental Gardens was a private botanical garden built by George W. Clark over a period of 25 years. In 1938, the public was allowed to enter for a nominal fee. The gardens consisted of over 18 acres of gardens, lakes, and streams, with bridges and arches carrying out an Oriental theme, and extended from San Jose Boulevard to the St. Johns River. It boasted hundreds of species of subtropical plants and trees. It closed in 1954, and a housing subdivision was built in its place.

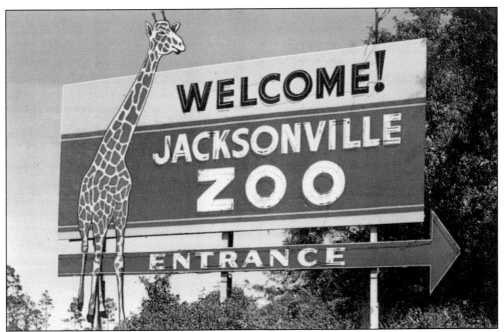

Jacksonville's residents were intrigued by wild animals and wanted a city-owned animal display. This led to Jacksonville's first city zoo, which opened on May 12, 1914. It was located in Springfield Park near Third and Broad Streets. A single red deer in a cage was the zoo's first attraction. (Colourpicture.)

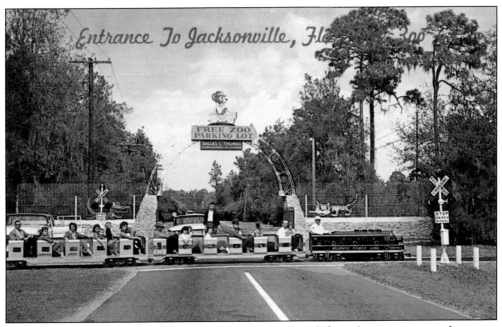

City Commissioner St. Elmo "Chic" Acosta campaigned for a larger, more modern zoo. Eventually 40 acres of property on the south bank of the Trout River were purchased, and on July 19, 1925, the City of Jacksonville's Free Zoo was opened. Featured at the zoo was the "fascinating one mile ride on the miniature Zoo Railroad." (Marsh Post Card Service.)

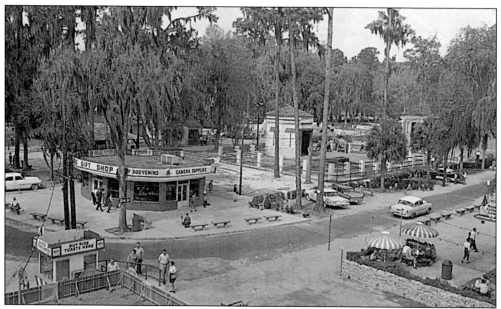

The tree-shaded banks of the Trout River, an ideal location for the zoo, provided visual education, relaxation, and recreation for residents and visitors alike. This aerial view, as seen from the top of the Ferris wheel, shows some of the amenities and attractions at the zoo. Parking was conveniently located within the zoo. Today the parking is located outside the zoo gates but is still free. (Marsh Post Card Service.)

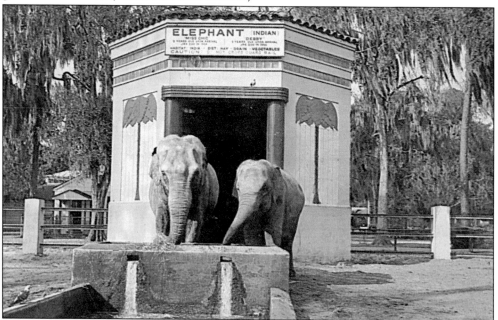

Once again, St. Elmo "Chic" Acosta set out to improve the zoo. He wanted an elephant. Three years of fund-raising produced the $3,000 needed to purchase an Indian elephant; she was named "Miss Chic" in honor of Acosta. In 1935, an octagonal, art deco–styled Elephant House was designed by Roy Benjamin. Unfortunately this unique structure was demolished. (Marsh Post Card Service.)

Ten

CAMP JOHNSTON

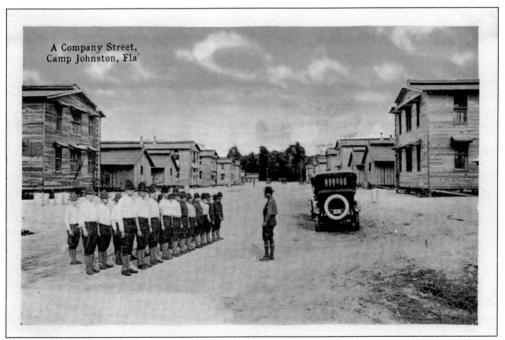

In 1909, the National Guard of Florida established a base at Black Point, where a neck of land extends outward into the St. Johns River. Prior to World War I, Jacksonville business and political leaders lobbied for a military base camp at this same strategic point. Eventually a decision was made to establish a quartermasters' training camp at Black Point, now the site of Jacksonville Naval Air Station.

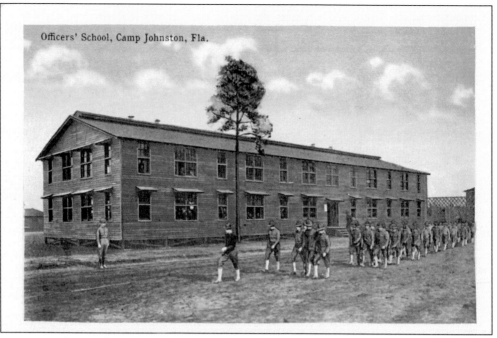

Camp Joseph E. Johnston was named after a famous Confederate general. It was a major training center for army quartermasters and the hopping off spot from America for the trenches of France.

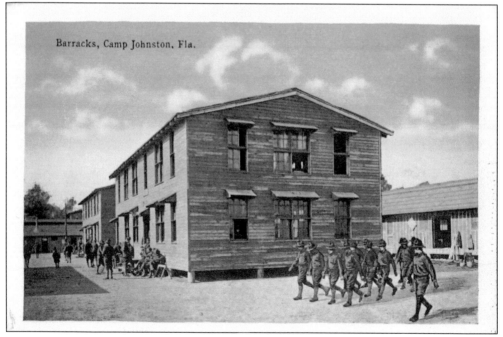

During World War I, there were as many as 27,000 quartermaster troops in training at Camp Johnston. There were over 600 wooden structures at this strategic campsite.

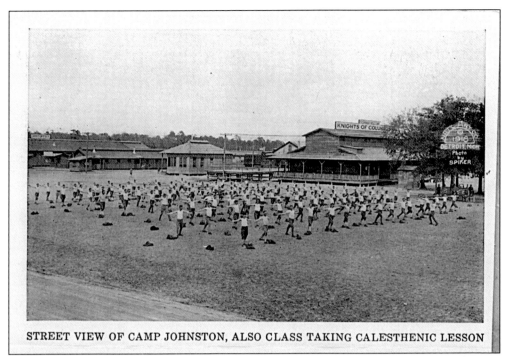

STREET VIEW OF CAMP JOHNSTON, ALSO CLASS TAKING CALESTHENIC LESSON

Lt. Blair Burwell was enlisted in December 1917 and was stationed at Camp Johnston for six months. In a 1939 interview, Burwell described his time spent at the camp. He said, "There were daily workouts . . ."

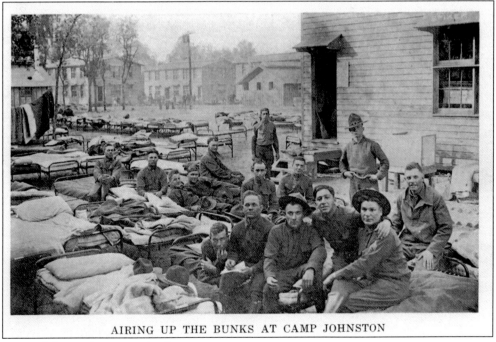

AIRING UP THE BUNKS AT CAMP JOHNSTON

". . . and the work was routine."

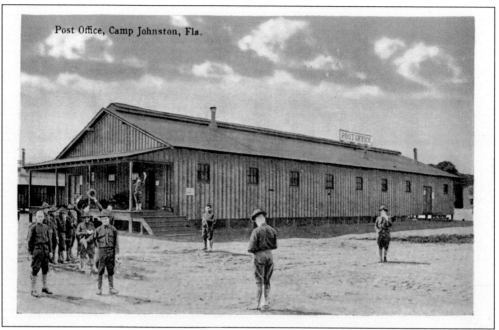

Post Office, Camp Johnston, Fla.

Richard A. Martin, a *Florida Times-Union* Centennial Edition editor, wrote about Camp Johnston and the soldiers stationed there: "As the soldier dozed off for the night he thought of the perfect day: 'A dozen letters, a box of chocolates, some sweet cookies from home, a new photo of your sweetie, a furlough and pay the same day.' Reveille brought him back to earth."

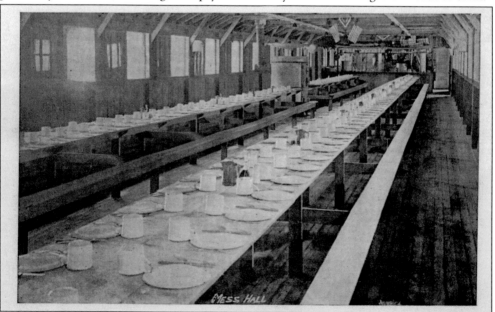

"Like all soldiers, the boys at Camp Johnston loved their chow. But a scandal developed early in the camp's history when dissatisfied soldiers, away from their mothers' cooking for the first time, wrote letters of protest to families in Jacksonville. Southern hospitality prevailed, and the families opened their doors to the homesick soldiers. The young soldiers were invited to Sunday dinners and evening entertainments," wrote Richard A. Martin.

124

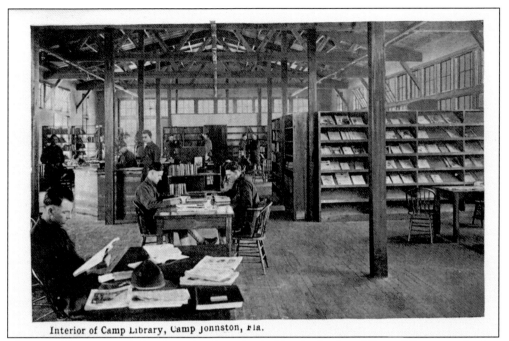

Interior of Camp Library, Camp Jonnston, Fla.

The camp library provided technical and mechanical books for the soldiers while not neglecting their need for recreational reading. There were over 17,000 volumes in the camp library and hundreds of magazines and pamphlets. The library provided seating for 150 men.

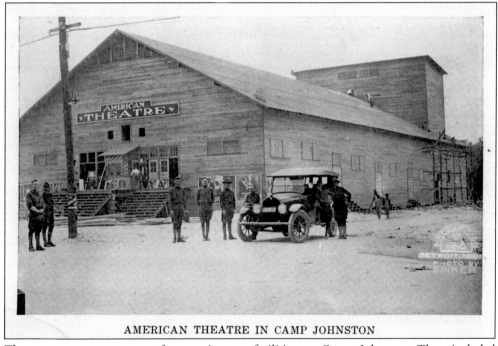

AMERICAN THEATRE IN CAMP JOHNSTON

There was an assortment of entertainment facilities at Camp Johnston. They included the American and Liberty Theatres, a bowling alley, a library, and five Knights of Columbus Halls.

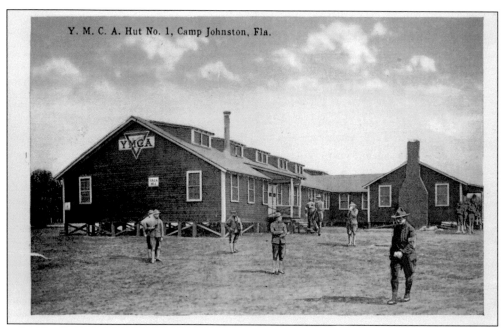

Y. M. C. A. Hut No. 1, Camp Johnston, Fla.

The camp newspaper was called *Trench and Camp*. The first issue came out on January 5, 1918, and the last on January 16, 1919. Each week, between 6,000 and 25,000 issues were printed by the *Florida Times-Union*. It was distributed under the cosponsorship of the YMCA, which was very active in camp life.

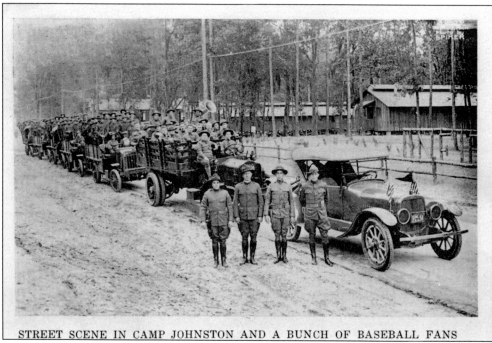

STREET SCENE IN CAMP JOHNSTON AND A BUNCH OF BASEBALL FANS

"Everyone agreed that one good thing about Camp Johnston was its lack of mud. Sandy soil was ideal because it absorbed rain quickly, cutting down on the mud and slush familiar to the other cantonments in the country," as described by Richard A. Martin.

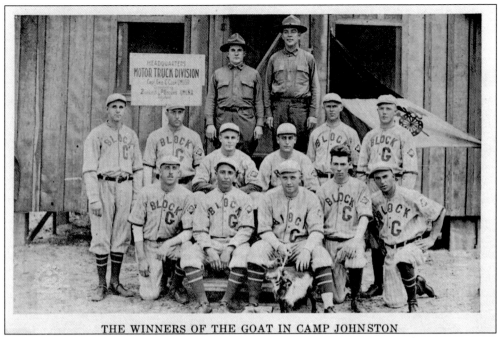

THE WINNERS OF THE GOAT IN CAMP JOHNSTON

Sports were a part of life at Camp Johnston. There was everything for the soldier from table tennis to shadow boxing and football. Camp Johnston had a top-notch baseball team. The professional Philadelphia Athletics were defeated by the soldiers, and the Pittsburgh Pirates had to go 10 innings to beat the camp team," wrote Richard A. Martin.

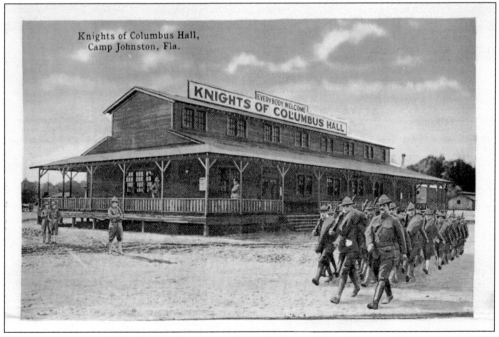

On November 11, 1918, World War I ended, and Jacksonville celebrated. There were parades and marches; soldiers were everywhere. Noise-making instruments, large and small, intensified the reality that the war was over. Camp Johnston demobilized almost immediately.

Discover Thousands of Local History Books
Featuring Millions of Vintage Images

Arcadia Publishing, the leading local history publisher in the United States, is committed to making history accessible and meaningful through publishing books that celebrate and preserve the heritage of America's people and places.

Find more books like this at
www.arcadiapublishing.com

Search for your hometown history, your old stomping grounds, and even your favorite sports team.